Turner

in The National Gallery of Ireland

Turner

in The National Gallery of Ireland

Barbara Dawson

THE NATIONAL GALLERY OF IRELAND

For Paul (E.P.)

First published, 1988, by the National Gallery of Ireland, Dublin 2.

Edited by Elizabeth Mayes.
Colour photography by John Kellett; monochrome by Michael Olohan.
Colour separation and platemaking by Kulor Centre Ltd., Dublin.
Design, origination and print production by Printset and Design, Ltd., Dublin.

Printed in Ireland by Criterion Press Ltd., Dublin.

Cover: detail of *Great Yarmouth Harbour, Norfolk* (Pl.28)

British Library Cataloguing in Publication Data
Dawson, Barbara,
 Turner in the National Gallery of Ireland.
 1. English water colour paintings.
 Turner, J.M.W. (Joseph Mallord William),
 1775-1851. Catalogues, indexes
 I. Title
 759.2

ISBN 0-903162-46-6

Contents

Foreword

The art of J.M.W. Turner, with both its serene and awesome images of nature, holds a particular fascination for modern society. The world in which we now live, daily threatened with pollution, not to say destruction, is a fragile place, the beauty and fascination of which is marvellously rendered in the protean paintings and watercolours of Turner. Down through the years his many faceted visions of the landscape of Britain and Europe have gained rather than diminished in their power of attraction since their creation over one hundred years ago.

This at least would appear to be the verdict of the many thousands of admirers who annually flock to view the collection of watercolours and drawings by the master in the National Gallery. Almost all of these works, through the intelligence and foresight of Henry Vaughan, who in 1900 bequeathed to the gallery thirty-one out of the total of thirty-five pieces in our care, have remained in virtually pristine condition. It was a stipulation in Vaughan's will that his watercolours and drawings should be exhibited only during the month of January so as to protect them from the harmful effects of excessive exposure to strong light.

For many years the public have craved some form of adequate, permanent record of these fascinating compositions to satisfy their apparently insatiable curiosity about them. It is to satisfy this need that the Board of Governors and Guardians of the National Gallery have commissioned this volume. In it the marvellous state of preservation of these ephemeral masterpieces is beautifully reproduced for the first time, accompanied by Barbara Dawson's intelligent and informative text.

For almost two years Barbara Dawson has diligently researched the collection, which charts almost every phase of the artist's development, from his earliest topographical views to his days at Dr. Monro's Academy and his later peripatetic ramblings about Britain and his expeditions across Europe. In her discussion on each of the works she carefully documents all the known information, while keenly seeking out new insights into their genesis and significance. Barbara Dawson's detailed commentary, together with John Kellett's skilful photography, have here combined to produce a catalogue which, we trust, will be warmly welcomed by all those who admire the genius of Turner.

RAYMOND KEAVENEY,
Director, The National Gallery of Ireland
December 1988.

Author's Acknowledgements

The watercolours by Joseph Mallord William Turner R.A. at the National Gallery of Ireland are a beautiful and interesting collection of the artist's work. Consisting almost totally of Henry Vaughan's magnificent bequest to the Gallery in 1900 (there are four works outside the bequest), the collection ranges from early landscape sketches to late, intricately wrought compositions.

I am most grateful to Homan Potterton for inviting me to write this catalogue, which is intended to give the reader some insight and information on the Turner Collection in Dublin. Not the last word by any means — is there ever a last word on any of Turner's works? However, I will gladly welcome any observations or criticisms which scholars may wish to put forward.

In compiling this catalogue, I carried out much of my research in the Prints and Drawings Department at the British Museum. There I would particularly like to thank Ann Forsdyke, Frances Dunkels and Lindsay Stainton.

My research at the Clore Gallery was assisted by the Curator, Andrew Wilton, Ann Chumbley and Ian Warell; and at Thomas Agnew & Son by Christopher Kinzett. I also wish to thank Louise Doyle Kelly for her assistance. She and her husband Donal Gallagher were most hospitable.

In Dublin, at the National Gallery of Ireland I wish to extend my thanks to the staff, particularly Raymond Keaveney, Maighread McParland, Susan Corr and Matthew Cains, Janet Drew, Adrian Le Harivel, Mary Lynagh, Kim-Mai Mooney and Wanda Ryan-Smolin. Elizabeth Mayes edited the text with patience and skill and Fionnuala Croke compiled the index. The photography was carried out by John Kellett. A special mention must go to Mary Cousins, Paula Hicks and Orla O'Reilly who, with good humour and thoroughness, typed up the text. The attendants were also most helpful particularly, Gabriel Bregazzi, William Carrick, Michael O'Brien and Michael O'Shea.

The Library staff at Trinity College, Dublin, especially Katherine Swift, Keeper of Early Printed Books, also readily assisted my research.

I am grateful to Mary Catherine O'Reilly for compiling the map, to Irene Dunne for unlocking the mysterious workings of the word processor and especially to my mother, Kit Dawson, for her encouragement over the years.

Finally the biggest thank you of all goes to my husband, Paul McGowan, who through his continued support, perseverance and interest in my research made this catalogue possible.

Barbara Dawson

For the Reader

The term drawing is also used in this text to denote watercolour.

All illustrations in the catalogue are by Turner unless otherwise indicated.

Books and abbreviations most often referred to:

B/J: Martin Butler and Evelyn Joll, *The Paintings of J.M.W. Turner.*
 2 vols. (London/New Haven 1977)

Farington: *The Diary of Joseph Farington*, edited by Robert Garlick, Angus
 MacKintyre and Kathryn Cave. 16 vols. (New Haven/London 1978 -
 1984).

Finberg: A.J. Finberg, *The Life of J.M.W. Turner* (London 1939, 2nd ed. 1961,
 1967)

R.A.: Royal Academy, London

Rawlinson: W.G. Rawlinson, *The Engraved Work of J.M.W. Turner.*
 2 vols. (London 1908).

T.B.: A. J. Finberg, *A Complete Inventory of the Drawings in the Turner
 Bequest.* 2 vols. (London 1909)

W: Andrew Wilton, *Turner's Art and Life* (Fribourg 1979) Part II,
 Watercolour catalogue.

'Man is in part divine,
A troubled stream from a pure source;'

Lord Byron, *Prometheus*

Frontispiece: *Joseph Mallord William Turner*
by C. Turner (National Portrait
Gallery, London, cat. no. 1182).

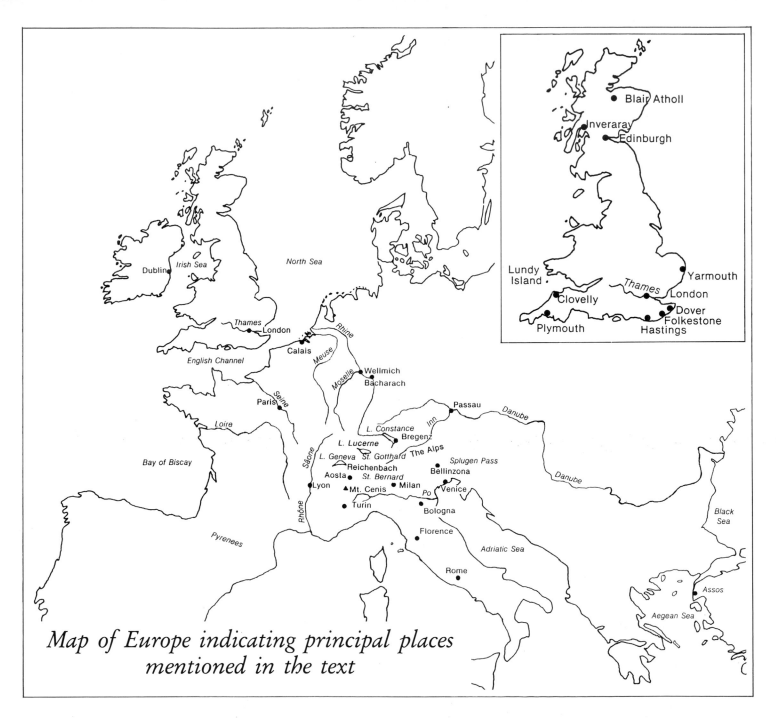

Map of Europe indicating principal places mentioned in the text

Chronology of J.M.W. Turner's Life

1775 April 23: Joseph Mallord William Turner born at 21 Maiden Lane, Covent Garden, London. Son of Mary Marshall and William Turner, a barber and wig-maker.

1778 Turner's sister, Mary Ann, baptised at St. Paul's Covent Garden.

1784 Earliest known drawings: views of Margate and its neighbourhood.

1785 Turner sent to Brentford, Middlesex, to stay with his maternal uncle, Joseph Mallord Willam Marshall.

1786 Death of Mary Ann.

1787 Earliest signed and dated drawings.

1789 Date of his first sketchbook of original drawings from nature, carried out in London and in the neighbourhood of Sunningwell near Oxford, where he stayed with his uncle who had retired there from Brentford. At this time, probably studied under Thomas Malton, the architectural draughtsman.
December 11: Admitted as a student at the Royal Academy Schools.

1790 Exhibited his first watercolour at the Royal Academy, *The Archbishop's Palace, Lambeth.*

1791 Sketching tour in Somerset and Wiltshire.

1792 Sketching tour of South Wales.

1793 March 27: Received the 'Greater Silver Palette' award for landscape drawing by the Society of Arts.
Autumn: Sketching tour of Sussex and Kent.

1794 Began his three year partial apprenticeship at Dr. Monro's Academy where he made copy drawings from works in the doctor's collection. First engraving was published in *The Copper Plate Magazine - View of the City of Rochester.* Sketching tour of the Midlands and North Wales.

1795 Tour of South Wales and Isle of Wight.

1796 Exhibited first oil painting at the Royal Academy - *Fishermen at Sea.* (B/J 1.)

1797 Tour of the North of England, including the Lake District. Visited William Lock at Norbury Park where he made sketches of the famous beech trees.

1798 Trip to Malmesbury, Bristol and North Wales. Acquired a mistress, Mrs. Sarah Danby, who bore him two daughters, Evelina and Georgiana.

1799 Approached by Lord Elgin to accompany him on a trip to Athens for purpose of making architectural drawings. Failed to agree on a salary. Stayed with William Beckford at Fonthill for three weeks. Trip to Lancashire and North Wales
November 4: Elected an Associate of the Royal Academy
November - December: Moved to 64 Harley Street.

1800 First use of verse to accompany title of painting in Royal Academy Exhibition catalogue. Turner's mother admitted to Bethlem Hospital for the Insane.

1801 First tour of Scotland where he made many sketches of Edinburgh Castle.

1802	Elected a full member of the Royal Academy. First trip abroad, to France and Switzerland with extended visits to the Louvre.
1804	Death of Turner's mother in a private asylum in Islington. April: Opening of Turner's own gallery at 64 Harley Street. Acquired a cottage on the Thames, Sion Ferry House, Isleworth.
1805	April 22: Opening of the first exhibition of the Society of Painters in Water-Colours, founded in 1804.
1806	Exhibited for the first time at the British Institution. His friend, W.F. Wells of Knockholt, Kent, suggested the *Liber Studiorum* project. Took a house at 6 West End, Upper Mall, Hammersmith.
1807	June 11: First volume of the *Liber Studiorum* published. November 2: Elected Professor of Perspective at the Royal Academy. Bought land at Twickenham with intention of building himself a house there.
1808	Trip to Cheshire. Stayed with Sir John Leicester at Tabley House. Sketched along the river Dee.
1809	First visit to Petworth House as guest of Lord Egremont.
1810	Acquired 47 Queen Anne Street, which became his permanent London residence. Stayed with Walter Fawkes at Farnley Hall, Yorkshire.
1811	First lecture as Professor of Perspective at the Royal Academy. Commissioned by William Bernard Cooke to provide illustrations for his forthcoming publication *Picturesque Views of the Southern Coast of England*. December 10: Elected a Visitor in the Royal Academy Schools.
1812	Exhibited *Snow Storm: Hannibal and his Army crossing the Alps* at the Royal Academy. Catalogue entry was accompanied by the first quotation from his own composed verses entitled *Fallacies of Hope*. Began building house at Twickenham and had temporary residence at Sion Ferry House, Isleworth.
1813	Solus (later known as Sandycombe) Lodge, Twickenham, was completed to his designs. Tour of the West Country, collecting further material for *Picturesque Views of the Southern Coast of England*.
1815	Sketching tour of Yorkshire. Elected by the Royal Academy as one of the visiting artists at the new School of Painting at the Academy.
1816	Tour of North England, partly to gather material for Whitaker's *History of Richmondshire*.
1817	First visit to Belgium, the Rhine between Cologne and Mainz, and Holland. Returned via Durham where he gathered material for a series of views commissioned by Lord Strathmore. His daughter, Evelina, married Joseph Dupuis, who in 1818 became Consul in Ashanti.
1818	Commissioned by James Hakewill to make illustrations for his publication *Picturesque Tour in Italy*. Visited Scotland to gather material for Scott's *The Provincial Antiquities of Scotland*. Acquired lease of 47 Queen Anne Street West. He also secured the leases of nos. 65 and 66 Harley Street. He annexed the gardens to that of the house in Queen Anne Street and began building his new gallery which opened in 1822.
1819	March: Sir John Leicester's collection of

British Modern paintings opened to the public at his house in Hill Street, Mayfair. April 13 - mid-June: Exhibition of Walter Fawkes collection of contemporary English watercolours at his town house, 45 Grosvenor Place. About sixty watercolours by Turner.

August: First trip to Italy - Turin, Como, Venice, Rome and Naples. Wintered in Rome and returned to London in February 1820 via Florence, Turin and the Mont Cenis Pass.

1820　February 1: Arrived back in London.
April - June 22: Fawkes Collection opened again to the public.

1821　Trip to Paris.
December 30: Death of Joseph Farington.

1822　February 1: Exhibition of *Drawings of English Artists* at W.B. Cooke's premises, 9 Soho Square which included those watercolours by Turner for Cooke's publications. These were exhibited again in 1823 and 1824.
April: Turner's new Gallery in Queen Anne Street opened to the public.
August: Visited Edinburgh for the State visit of George IV.

1823　May: W.B. Cooke's second exhibition of watercolours at Soho Square.
August: First part of the *Rivers of England* series was issued. Commissioned by George IV to paint *The Battle of Trafalgar* for St. James' Palace.
December 10: Elected Auditor to the Royal Academy

1824　April: W.B. Cooke's third exhibition of watercolours at Soho Square. Tour of East and South East of England.

1825　Charles Heath commissioned one hundred and twenty watercolours from Turner for *Picturesque Views in England and Wales*.
August 28: Tour of Holland, the Rhine and Belgium.
October 25: Walter Fawkes died.

1826　*Ports of England* views issued between 1826 and 1828. Only six of the twelve plates were published. The remainder did not appear until 1856. Tour of the Meuse, the Moselle, Brittany and the Loire. Conclusion of the series *Picturesque Views of the Southern Coast of England*.

1827　First part of *Picturesque Views in England and Wales* appeared
August-September: Visited Sir John Nash at East Cowes Castle on the Isle of Wight.

1828　Last series of lectures as Professor of Perspective.
August: Second visit to Italy - Paris, Lyon, Avignon, Florence and Rome.

1829　February: Returned from Italy via Loreto, Ancona, Bologna, Turin, Mont Cenis and Lyons.
June - July 18: Charles Heath held an exhibition at the Egyptian Hall, Piccadilly. About forty watercolours by Turner were shown, principally subjects from the *England and Wales* series. Many of the drawings were acquired by Thomas Griffith of Norwood, later to become Turner's agent.
August: Visited Paris, Normandy and Brittany.
September 21: Death of Turner's father.

1830　Tour of the Midlands. Samuel Roger's *Italy* published, with vignettes by Turner.

1831　Tour of Scotland in connection with his illustrations for Scott's *Poetical Works* (1834).

1832	March: Twelve finished watercolours for Scott's *Poetical Works* were exhibited at Messrs. Moon, Boys and Graves, Pall Mall; more drawings were shown there in 1833 and 1834. Visited Paris where he possibly met Delacroix. Met Mrs. Sophia C. Booth in Margate, who became his landlady and companion.
1833	June: First volume of *Turner's Annual Tour - Wanderings by the Loire and the Seine* was published, with text by L. Richie. Produced first watercolours for *Finden's Bible*. Autumn: Tour of Central Europe via Copenhagen, going south to Berlin. Travelled along the Danube, crossed into Italy and visited Verona and Venice.
1834	Illustrations for William Finden's publication, *Life and Works of Lord Byron*, were exhibited at Colnaghi's. *Finden's Bible* began to appear in monthly parts. July: Tour of the Meuse, Moselle and Rhine.
1836	Publication of *Finden's Bible*. Toured France, Switzerland and the Val d'Aosta with H.A.J. Munro of Novar. October: Ruskin's first letter to Turner enclosing his reply to an attack on the artist in *Blackwood's Magazine*.
1837	July-August: Visited Paris and Versailles and neighbourhood. November 11: Death of Lord Egremont. December 28: Resigned post of Professor of Perspective.
1839	August: Tour of Belgium, the Meuse and the Rhine.
1840	June 22: Met Ruskin for the first time at Norwood, the home of his agent, Thomas Griffith. Tour of the Rhine, Bregenz, Venice, Innsbruck, Passau, Nuremberg, Coburg and Heidelberg. Turner together with other artists made a presentation to Thomas Griffith for his services in selling their work.
1841	June 1: Sir David Wilkie died. August to October: Visited Switzerland, Lucerne, Constance, Zurich and Bellinzona. Asked Griffith to find commissions for ten finished watercolours. November 25: Death of Sir Francis Chantrey.
1842	May 25: Bankruptcy of William and Edward Finden. August to October: Visited Switzerland.
1843	May: First volume of *Modern Painters* by John Ruskin published. Intended mainly as a defence of Turner's art. Summer: Visited Switzerland again.
1844	August to early October: Last visit to Switzerland, returning down the Rhine to Rheinfelden, then to Heidelberg.
1845	May: Tour of Bologna and neighbourhood. July 14: Elected to carry out duties of President of the Royal Academy during Shee's illness. August: James Lennox of New York bought *Staffa, Fingal's Cave*. (B/J 347). First of Turner's paintings to go to America. September to October: Last trip abroad. Visited Dieppe and the coast of Picardy.
1846	Rented a cottage with Mrs. Sophia Booth at Cremorne New Road (now Cheyne Walk), Chelsea. Royal Hibernian Academy exhibition included *Saltash with the Water Ferry*, (B/J 121) and *Whalers* (B/J 414).
1847	The American photographer, J.J.E. Mayall, set up a studio in London where Turner was a frequent visitor until 1849.
1848	First oil painting hung in the National

Gallery, London: *The Dogano, San Giorgio, Citella, from The Steps of The Europa* represented the Robert Vernon gift.

1851 No exhibits at the Royal Academy.
December 19: Died at his cottage, 119 Cheyne Walk, Chelsea.
December 30: Buried at St. Paul's Cathedral.

1852-1857 In 1852, Turner's relatives contested probate of his will, claiming that he had been of unsound mind. A long drawn out chancery suit followed. The dispute was finally resolved with a compromise agreement. Turner's money, almost £140,000 and property, which he wished to leave for the establishment of a charity for Decayed Artists, was divided among his relatives. The contents of his studio was left to the State. Known as The Turner Bequest, the collection is now housed at the Clore Gallery, London.

A preliminary catalogue drawn up in 1856 gave the total number of items in the Turner Bequest as 19,331. Of these some 19,049 were drawings. The remainder included 100 finished and 182 unfinished paintings.

Introduction

When Joseph Mallord William Turner died in December 1851 he left behind not only the reputation of being one of the greatest landscape painters ever, but also a legacy of superb oil paintings, finished watercolours and watercolour sketches. Throughout his long life he was a tireless worker and the resulting innovative works are still under constant study and assessment. John Ruskin (Fig. 2), the famous English nineteenth century writer and author of *Modern Painters*, a masterly defence of Turner's art, heard of Turner's death while he was residing in Venice. He wrote to his father in London urging him to purchase not the finished oils and watercolours which he imagined would come on the market and which were more popular, but Turner's watercolour sketches. He continues in his letter 'I can get *more* out of Turner at a cheaper rate thus' (Ruskin believed Turner's sketches would sell cheaply as they would not be in as great demand as his finished works) 'than any other way. I understand the meaning of these sketches - and I can work them up in to pictures in my head - and reason out a great deal of the man from them which I cannot

Fig. 1. Monogram of J.M.W. Turner from *Shipping* (Pl. 14) (National Gallery of Ireland, cat. no. 2401).

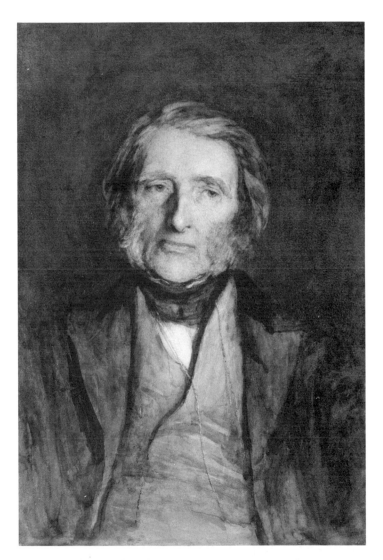

Fig. 2. *John Ruskin* by H. von Herkomer (National Portrait Gallery, London, cat. no. 1336).

from the drawings' (i.e. the finished watercolours in Ruskin's collection).[1] This correspondence emphasises the great artistic value Ruskin placed on Turner's watercolour sketches, which were carried out by the artist on his many sketching tours around Britain and on the continent.

The value Ruskin placed on these watercolour sketches is of particular interest to us, as the National Gallery of Ireland's collection of Turner's work is comprised largely of such watercolour sketches. As a landscape artist, Turner sought constant communion with nature. The vivid impressions which nature presented to him were instantly jotted down in the pages of his famous sketchbooks, revealing his keen insight and penetrating observations of the world about him. These sketches varied from slight pencil drawings to highly wrought colour impressions depicting the landscape views he encountered. It is interesting to note, however, that Turner's 'finished watercolours' were never sketched directly from nature. That concept of painting *en plein air* was to become popular later in the century in France with the arrival of the Barbizon school. Turner always carried out his finished works in his studio, and they were, generally speaking, executed either on commission or for exhibition.

In all his painting, both sketches and finished work, Turner's vision of nature was a highly personalised response to the landscape he observed. The resulting works were a unique interpretation of what he saw, painted in a dramatic innovative style which broke with the more traditional classical manner adopted by earlier masters. His treatment of form, which ranged from precise detailed images to loose, almost out of focus suggestions of objects, together with his exuberant colouring, created a revolutionary style of landscape painting. But not only was his style unique, his concept of nature was equally individual. George Jones in his biography of Sir Francis Chantrey R.A. (1781-1841) (Fig. 3) recounts an incident at the Royal

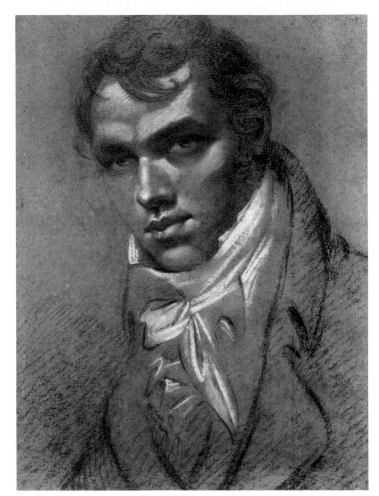

Fig. 3. *Self Portrait* by Sir Francis Chantrey (National Portrait Gallery London, cat. no. 654).

Academy when Turner and his friend Sir Francis were examining the works sent for exhibition. A drawing of *The Falls of Terni* was under discussion which Turner declared was a copy from his drawing of the same scene. The secretary of the Royal Academy, Mr. Howard, suggested perhaps the artist in question had also visited the Terni Falls in Italy and made a similar drawing without ever having seen Turner's work. Chantrey replied for Turner, saying 'No, no, if the

artist had ever been there, his drawing would not be like Turner's'. He thus implied that Turner's views, while distinctly recognisable from the local landmarks, contained an aspect, colouring and atmosphere which resulted from his unique viewpoint of the scene observed. Nonetheless, despite his innovative style, Turner remained true to nature, advocating as faithful as possible a representation of the view observed. Commenting on a sketch of a town shown to him, Turner asked the artist why he had left out the church spire. The artist replied he had not had time to include it. 'Then', said Turner, 'you should have taken a subject more suited to your capacity.' This direct piece of advice resulted from Turner's earnest requirement that one should paint wholly the scene observed, not just select bits and pieces which when fitted together form a picture.

Unlike most other artists, Turner's talents were expressed equally in both oil and watercolour. It was through his masterly use of watercolour, however, that new possibilities of pictorial expression were revealed. Watercolour painting was still in its infancy at the end of the eighteenth century. Throughout the eighteenth century and earlier, watercolours were employed primarily for topographical views or pictorial designs. The drawings were executed in indian ink, highlighted by a few tints of local colour. Over the outlines a pale transparent wash of colour was applied in an effort to bind the elements together. Watercolour was regarded primarily as an objective means of record rather than a distinctive mode of expression. Certainly it was not considered suitable for the painting of 'noble art'. As late as 1795, Joseph Wright of Derby remarked that 'Paper and camel hair pencils (i.e. brushes) are better adapted to the amusement of ladies than to the pursuit an artist'.[2] Artists who intended to pursue a serious career in painting concentrated on applying their skills to oil painting. This practice was encouraged by the Royal Academy which ruled that artists who worked solely in watercolour should not be allowed full academic honours. Turner was of course aware of this and as early as 1796 he exhibited his first oil painting *Fishermen at Sea* (Tate Gallery, London) (B/J 1) at the Royal Academy. After his election to full membership of the Royal Academy in 1802 he rarely exhibited watercolours there, preferring to carry out these drawings on commission from patrons or publishers.

Like many other promising artists of the time, Turner began his career by making topographical drawings, placing the emphasis on medieval architectural features. Such drawings were much in demand at the end of the eighteenth century and through their circulation Turner was brought to the notice of both collectors and publishers. As early as 1793, at the age of eighteen, he received his first private commission from *The Copper Plate Magazine*. This publication had begun, at the turn of the century, to include a series of British medieval views in their monthly editions. These drawings of medieval fortresses and settlements provided a nostalgic reminder of the splendour of the Middle Ages, memories of which the romantics of the nineteenth century were eager to revive. Turner, among other artists, was only too willing to supply this market. His assured, precise draughtsmanship quickly found favour with the public. His success in these early years encouraged him to venture forth to the neighbouring countryside outside London in search of fresh material for his work. Within a couple of years, however, his careful studied sketches were abandoned for a freer, more individualistic view of nature.

Turner's quest for inspiration from nature encouraged him to travel extensively. Unlike Constable, who found fulfilment in the views around his beloved Stour Valley, Turner in his search to be true to nature journeyed further afield, throughout Britain as well as the continent. Indeed Turner's continental travels were quite amazing feats of endurance. Many of the

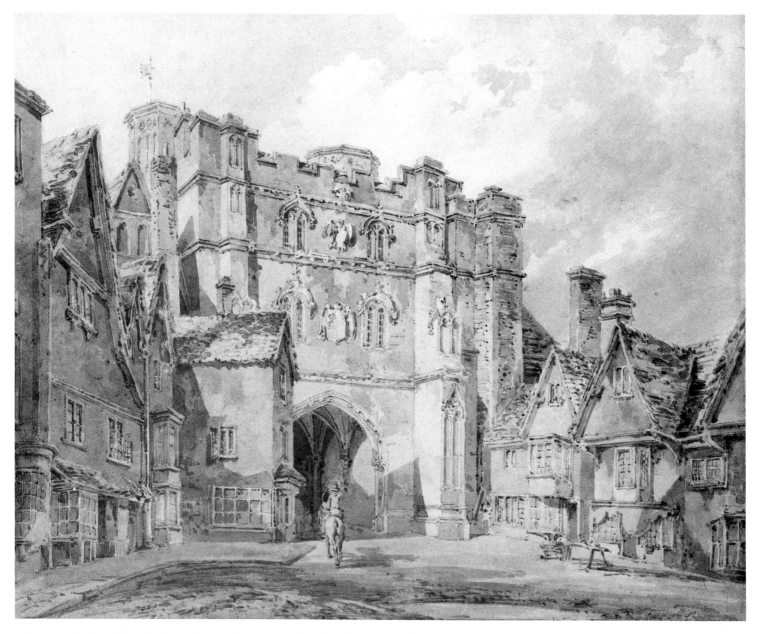

Fig. 4. *Christ Church Gate, Canterbury*, 1793/94 (Yale Centre for British Art, Paul Mellon Collection, cat. no. B1986.29.494). Watercolour.

mountainous views he depicted were quite inaccessible, with the only mode of access being by foot. He made some nineteen sketching trips abroad, sometimes staying away for months at a time, as well as annual forays into the English countryside.

On one of Turner's early sketching trips to Kent and Sussex in 1793, he made a visit to the city of Canterbury. This famous medieval city offered ideal material for topographical views and consequently Turner made numerous architectural sketches of the city, most of which are in the *Canterbury and Rochester* sketchbook. (T.B. XV). The Dublin watercolour, *The West Gate, Canterbury* (Pl. 1), was most likely painted following this trip. During the early years of the 1790s much of Turner's exhibited work showed a considerable influence of Thomas Malton (1726-1801), the architectural draughtsman under whom Turner studied for a time c. 1789. *The West Gate, Canterbury*, however, is a more individual work. It shows a less marked influence of Malton's delineated crisp outlines and even shading. Turner's brushwork is looser, breaking up the light on the scene, giving the view a more immediate effect. Using broad washes of cool blues and greys, Turner, while allowing the medieval battlements to dominate, is careful to include the daily activities of the inhabitants. He does not simply use model studies to animate the scene, rather he presents us with a glimpse of daily life which is cleverly mirrored in the clear waters of the Stour River. The easy atmosphere which pervades is embodied in the relaxed pose of the labourer leaning against the doorway. Turner was evidently pleased with the drawing as he has signed it on the lower right hand side. He appears to have kept it for his own records as it was never exhibited by him. It contrasts with other drawings of Canterbury done about the same time. *Christ Church Gate, Canterbury*, (Fig. 4), for example, although a delightful work, is more studied, bearing a lingering influence of Malton's style.

Among the early works by Turner in the National Gallery of Ireland's collection are drawings carried out at Dr. Monro's evening classes (Pls. 3-9). Turner attended these classes in the winter months between 1794 and 1797. Dr. Monro, a notable collector of watercolours, was an ardent supporter of watercolour painting. At these evening classes he made his fine collection of watercolours available to young students who were encouraged to study these earlier artists' styles and to make copy sketches from their work. Monro then bought these copy drawings from the students, so they were well rewarded for their evening's work. Among the artists represented in Monro's collection were Thomas Gainsborough, Thomas Hearne, Edward Dayes and John Robert Cozens. Turner, like the other students who attended Monro's classes, made copy drawings from these artists' work, imitating their style most convincingly. Dayes' influence is clearly evident in the two scenes of Dover harbour (Pls. 6 and 7), while the flat Italianate landscape in *A river in the Campagna* (Pl. 9) suggests the influence of Thomas Hearne.

The most revolutionary artist represented at the 'Monro Academy' was John Robert Cozens. Monro, by chance, came into temporary possession of Cozens' Italian sketchbooks which the artist used on his travels in Italy between 1782 and 1783. Monro made these sketchbooks available to his students who made copy sketches from them. *The View of Velmo near Terni* (Pl. 3) is a direct copy from one of Cozens' sketches. As Cozens' use of watercolour was both imaginative and innovative, it would have made a distinct impression on Turner. His poetic watercolours were impressive and made a considerable impact on the development of watercolour painting, in that form, space and depth are indicated through subtle gradations of light and shade which were harmoniously blended into a pictorial unity resembling that of oil painting. Working in a low colour key, Cozens applied his

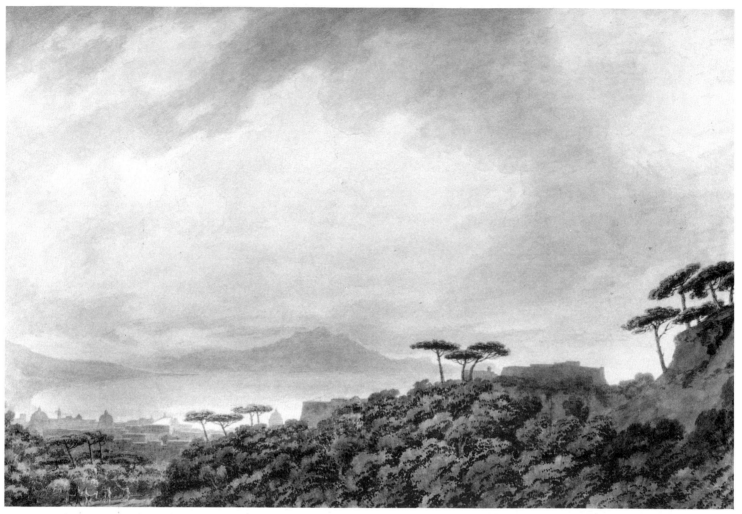

Fig. 5. *The Bay of Naples from Capodimonte* by John Robert Cozens (National Gallery of Ireland, cat. no. 2068). Watercolour.

colour sparingly, carefully overlapping the brushstrokes in those areas where he wished to indicate greater depth or volume. Broad areas of wash are swept over the scene which, with the slight quivering outlines of the objects depicted, further emphasise the gentle delicate structure of his work. His finished watercolours convey a subtle melancholic atmosphere which is echoed in his own personality (Fig. 5). Like Turner after him, Cozens found great inspiration for his landscapes in the Swiss Alps. He was one of the first British artists to convey in his Swiss landscapes the awesome majesty and disquietening effect of the lofty Alpine ranges (Fig. 6).

The first mountainous landscape encountered by

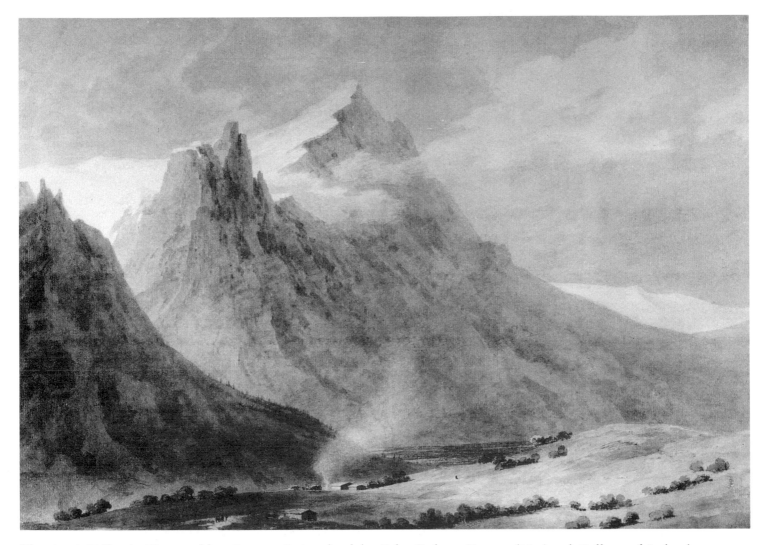

Fig. 6. *A Valley in Unterwalden Canton, Switzerland*, by John Robert Cozens (National Gallery of Ireland, cat. no. 2067). Watercolour.

Turner was in North Wales. He made a sketching trip there in 1798 and the magnificent landscape made a deep impression on him, encouraging in him a freer, more expressive, use of watercolour, somewhat reminiscent of Cozens' work. Three years after this trip to North Wales, Turner once again went north, this time to Scotland, where he made some large watercolours. These were more elaborate than any others he had previously designed. *Edinburgh from below Arthur's Seat* (Pl. 10) is one such work. The expressive moody scene is created through the use of a restricted range of low key colours. The grey sky, filled

Fig. 7. Detail of Turner's thumb print from *A ship off Hastings* c.1820 (Pl. 15) (National Gallery of Ireland, cat. no. 2412).

with ominous thunderclouds which threaten to engulf the castle, evokes an atmosphere of sublime nature, a theme which Turner would further develop in his sketches of Switzerland the following year.

In 1802, the uneasy Peace of Amiens agreed between France and Britain gave Turner his first opportunity to visit the continent and Switzerland in particular. He travelled by packet across the English Channel from Dover to Calais. He journeyed down to Paris where, together with his travelling companions, he bought a cabriolet for thirty two guineas. On their return to Paris they disposed of it once again. Buying a cabriolet or any such vehicle was the only means of procuring independent transport on the continent. Stage coaches did offer a service, but were restricted to a definite itinerary and set timetables. With private transport, it was possible to take an independent route, stopping when and where the party wished. This, however was the only time Turner ever used such luxurious transport. For the majority of his travels he relied on the limited public transport available, which on land was stage coach, then often walked miles to reach some planned destination.

From Paris, Turner travelled down to Lyon, then crossed over the Alps into Switzerland. This first visit was, for Turner, the beginning of a lifelong fascination with the Swiss landscape. His response to the Alpine scenery there resulted in highly wrought watercolour sketches executed with fervour and panache, evoking a feeling of the sublime. *The Great Fall of the Reichenbach* (Pl. 11) is a dispersed study sketch from the *St. Gotthard and Mont Blanc* sketchbook (T.B. LXXV), one of five sketchbooks Turner used on this trip. The enthusiasm and energy with which he approached this watercolour sketch can be judged from his methods of painting it. Turner has deliberately chosen a low colour key which is more expressive of the awesome power of the falls rather than a description of the scene. Throughout the drawing, flecks of white appear,

scratched out by Turner's thumb nail which was grown especially long for such use. Finger prints appear at the bottom of the waterfall and along the right side of the page, indicating how Turner used his fingers as well as brushes to blend in the paint. Finger prints are a familiar feature in many of Turner's watercolours, both in the finished works as well as in his sketches (Fig. 7).

Through his experimental use of watercolour, Turner found interesting, novel ways of achieving new effects. The famous nineteenth century diarist Joseph Farington R.A., who was acquainted with Turner, recounts in his diary of March 28, 1804, Turner's approach to painting his watercolours:

> 'The lights are made out by drawing a pencil (i.e. a brush) over the parts intended to be light (a general ground of dark colour having been laid where required) and raising the colour so damped by the pencil by means of *blotting paper;* after which with crumbs of the bread the parts are cleared. Such colour as may afterwards be necessary may be passed over the different parts. A white chalk pencil (Gibraltar rock pencil) to sketch the forms that are to be light. A rich draggy appearance may be obtained by passing a camel hair pencil *nearly dry* over them, which only *flirts* the damp on the part so touched and by blotting paper the lights are shown partially.'

The use of such methods to create landscape scenes betrays an instinctive feel for watercolour. Free from any technical inhibitions, Turner was constantly extending watercolour beyond its former limits of expression. His working methods astonished those who watched him paint. Farnley Hall in Yorkshire, the home of Walter Fawkes, his great friend and early patron, was one of Turner's favourite retreats outside London. There, *First-Rate taking in Stores*, a marine scene painted for Fawkes was executed in typical Turner fashion. It is described thus:

> '....he began by pouring wet paint on to the paper till it was saturated, he tore, he scratched, he scrabbled at it in a kind of frenzy and the whole thing was chaos - but gradually and as if by magic the lovely ship, with all its exquisite minutiae, came into being and by luncheon time the drawing was taken down in triumph.'[3]

Fawkes' daughters recount how they had seen in Turner's room, 'cords spread across the room as in that of a washer woman and papers tinted with pink and yellow hanging on them to dry.'[4] Turner immersed his sheets of paper in water before working on them. Even today one can see the buckled support of many watercolours, caused by such saturation. Turner continued to use such methods in executing highly detailed finished works. In B. Webber's *Biography of James Orrock 'RI'* (1903, vol. I, pp. 60-61 as quoted in Gage 1969), Orrock recounts that his master W. L. Leitch had told him.

> 'he once saw Turner working and this was on watercolour several of which were in progress at the same time. Mr. Leitch said he stretched the paper on boards and after plunging them into water, he dropped the colours onto the paper while it was wet, making marblings and gradations throughout the work.'

This unusual method of building up a watercolour composition indicates the confidence and assuredness with which Turner approached his work. There was no margin for error. The whole process was remarkably quick as W. L. Leitch confirmed:

> 'His completing process was marvellously rapid for he indicated his masses and incidents, took out half

Fig. 8. *J.M.W. Turner on varnishing day* by C.W. Cope (National Portrait Gallery, London, cat. no. 2943). Oil.

lights, scraped out highlights and dragged (i.e. dragged a nearly dry brush over the damp colour) hatched and stippled until the design was finished.'

Turner's procedure for working in oils was equally rapid. Many of his works sent to the Royal Academy in his latter years for completion on varnishing days were in a very unfinished state, consisting solely of gradations of colour. Gradations of blue, for example, would indicate sky or sea, while ochres and browns would indicate landscape. On varnishing days Turner worked up these canvases into highly finished detailed landscapes (Fig. 8).

Lionel Cust recounts how Turner worked on varnishing day:

'He (Turner) had been there all morning and seemed likely, judging by the state of the picture *(Regulus,* Tate Gallery, London) (B/J 294) (Fig. 9), to remain for the rest of the day. He was absorbed in his work, did not look about him, but kept on scumbling a lot of white into his picture - nearly all over it... the picture was a mass of red and yellow in all varieties. Every object was in this fiery state. He had a large palette, nothing on it but a huge lump of flake white: he had two or three biggish log tools to work with and with these he was driving the white into all the hollows and every part of the surface. This was the only work he did and it was the finishing stroke.... The picture gradually became wonderfully effective, just the effect of brilliant sunshine absorbing everything, and throwing a misty haze over every object. Standing sideways of the canvas, I saw that the sun was a lump of white, standing out like the boss of a shield.'[5]

Not satisfied with confining his energies to oil and watercolour painting, Turner was also keenly interested in engraving, realising in it great artistic potential. Between 1807 and 1819, Turner published a monumental series of engravings. This publication, entitled *Liber Studiorum,* contained seventy one plates, prototypes of Turner's approach to various categories of landscape painting: Mountainous, Pastoral, Elegant Pastoral, Historical, Architectural and Marine. He carried out the drawings in pen and sepia, then etched the outlines on copper plates before passing them on to a mezzotinter who finished them under Turner's

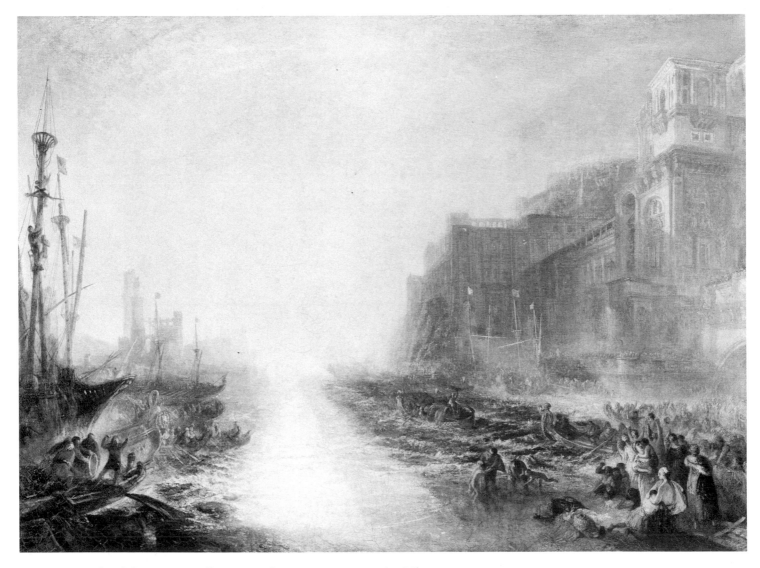

Fig. 9. *Regulus* (The Tate Gallery, London, cat. no. 00519). Oil.

careful supervision. Initially Charles Turner was employed to do the work, but, as the series advanced, other engravers were also employed. Turner himself completed some of the plates (Fig. 10). Turner's *Liber Studiorum* was inspired by Claude Lorraine's *Liber Veritatis* which contained one hundred and ninety five drawings, copies after his own paintings. Claude initiated such a compendium to ensure against forgery of his work. Turner, by contrast, did not produce his *Liber Studiorum* as an index of paintings but as a

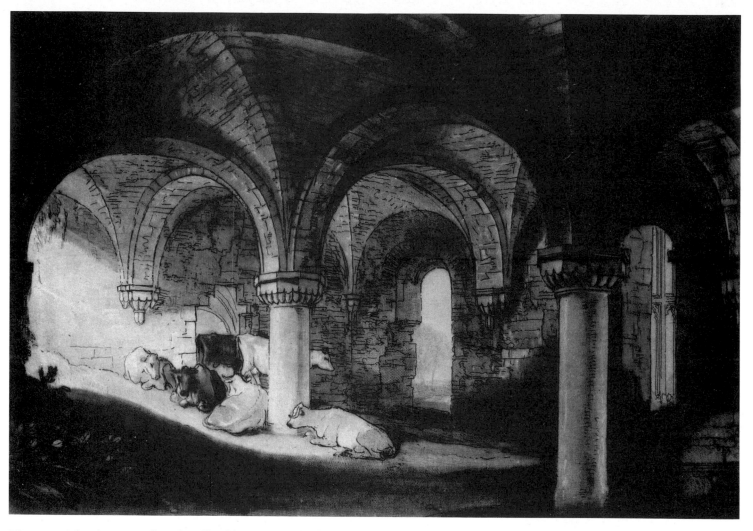

Fig. 10. *The Rectory of Kirkstall Abbey near Leeds, Yorkshire* (National Gallery of Ireland, cat. no. 11,996). Mezzotint from *Liber Studiorum*.

definitive example of the different categories of landscape painting. Due to his constant supervision of the work, the resulting plates are considered masterpieces of mezzotint engraving.

At the same time as working on the *Liber Studiorum*, Turner in 1811 embarked on another major project. He was commissioned to provide twenty four drawings for a publication entitled *Picturesque Views of the Southern Coast of England* (1814-26) which was published by William Bernard Cooke. This commission gave Turner his first opportunity to visit the south coast of England, where he could observe the ways of the

fishing folk who were in constant contact with the sea. Into this series of drawings Turner wrought an even greater complexity of design than he had hitherto achieved. Two of these designs are in the National Gallery of Ireland's collection. Completely different in mood and atmosphere, they convey the versatility of Turner's style. *A ship against the Mew Stone at the entrance of Plymouth Sound* (Pl. 12) is built up in dark washes of colour relieved by white highlights on the waves and in the sky. It is an exhilarating scene, frightening to behold, as the spectator immediately identifies with the precarious position of the fishing vessel. Working in a bold free style, Turner successfully conveys a monumental scene on a limited scale, losing none of the grandeur of the event. *Clovelly Bay* (Pl. 13) by contrast conveys daily life on the Devon Coast. In this view down the coast from the actual Bay of Clovelly, Turner records in precise detail the activities of the fishermen. The scene is conveyed in a calm tranquil atmosphere. The heat and languor suggested by the hazy blue sky and calm sea are echoed in the easy going manner of the fishermen. Both these drawings reveal a keen understanding and sympathy for these sea faring people and their uneasy but vital relationship with the ocean.

Conscious of his growing reputation and realising that through this series of engraved illustrations his work would be available to a greater audience, Turner worked closely with the engravers, requesting preliminary proofs from each of the plates. He wrote to W. B. Cooke on December 4, 1813

'....I likewise send back (by post) to prevent any (delay) by waiting for the carrier (until Tuesday) the print of your Brother's engraving [Turner here refers to George Cooke's engraving of Lands End], which I received only last night and as I do not recollect his direction in Gerwileth I shall in sending it to you beg you to assure him that I feel a reluctance to touch upon the sky or distance until he has done all he wishes to do or intends to do, and if he is confident in sending a fair translation of the drawing, that I have no wish to give him, you, or myself the trouble of another parcel...'[6]

Turner eventually quarrelled furiously with the Cooke brothers over this publication. After the series was completed he was to dispense with their services altogether. After his death the series was reprinted both by Virtue & Co., and Nattali. Turner would not have been so happy with such publications. He was aware that after so many takes the images on the copper plates became faint, with many of the subtle gradations of tone and fine lines disappearing altogether. Turner had a horror of prints being issued when the impressions had been worn to a shred. Thus he tried to protect his position by buying back plates which were threatened with over printing. His beautiful series of drawings for *Picturesque Views in England and Wales* (1827-38), despite the high quality of engraving and superiority of design, failed to appeal commercially. The publisher, Charles Heath, was forced to sell the stock of prints as well as the plates. The whole lot were put up for auction by Southgate and Co. in 1839. Just before the auctioneer was about to commence, Turner stepped in and bought the stock at the reserve price of three thousand pounds, much to many people's annoyance. Alaric Watts', 'Biographical Sketch' (as quoted in Finberg 1939, p. 374), recounts how Turner then went up to Henry Bohn the print seller who had been offered the stock prior to the auction, but who had refused to meet the price.

'So, sir you were going to buy my England and Wales, to sell cheap, I suppose - make umbrella prints of them, eh? - but I have taken care of that. No more of my plates shall be worn to shadows'.

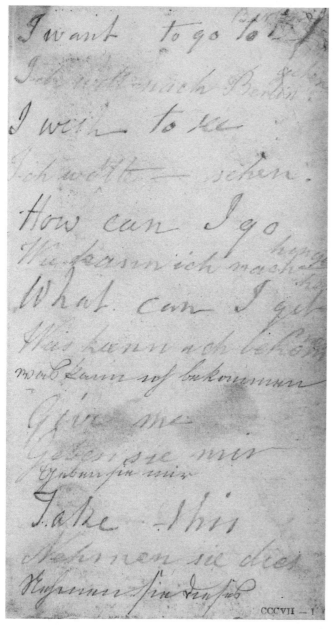

Fig. 11. Example of phrases from one of Turner's sketchbooks (T.B. CCCVII, Tate Gallery, London).

Such was his success with designs for engraving that throughout his career Turner continued to receive commissions from printers and publishers. For example, *Rivers of England* and *Ports of England* were published in the 1820s and *Views of the Seine and Loire* and Finden's *Landscape Illustrations of the most remarkable places mentioned in the Holy Scriptures,* generally known as *Finden's Bible,* in the 1830s. For the former publications Turner had first hand knowledge of the areas intended for illustration, making extensive trips to the places in question. The same, however, could not be said for the illustrations included in *Finden's Bible.* Turner's travels never included the Holy Land. Thus he was obliged to study views painted by visitors who had been there. The publishers chose the views on which they wished the drawings for the Bible to be based. One traveller to the Holy Land, whose views were chosen by the publishers, was the architect Sir Charles Barry (1795-1860) who, together with Augustus Pugin (1812-52), designed the new Houses of Parliament at Westminster. Turner particularly liked Barry's views of the Levant, as many of them were composed with an open vista of the scene, which Turner felt he could freely interpret. Of the twenty six drawings he made for *Finden's Bible,* fourteen are based on works by Sir Charles Barry, including the view of *Assos* (Pl. 20) in the National Gallery of Ireland's collection. The decay and ruin of that great Greek city is conveyed with poignant immediacy. Turner studied each of the supplied drawings with care, while he planned his treatment of the subject. When studying the sketch of *Pools of Solomon,* also by Barry, he told Ruskin he had kept it on his breakfast table for a month before he could make up his mind how to treat it. Biblical scenes were not, however, new to Turner. As early as 1800 he painted his first biblical work which was entitled *The Fifth Plague of Egypt.* Despite his lack of first hand knowledge of the Levant, Turner's images of the area were most realistic, incorporating in

them his own sharp, intuitive feel for the environment. The vortex of light emitted through the archway in *Assos* is similar in construction to the arc of light framing the arch below the bridge in *Le Pont du Château, Luxembourg* (Pl. 19). As Ruskin pointed out, Turner never drew anything that he himself had not observed. 'That is to say, though he would draw Jerusalem from some sketch, it would be, nevertheless entirely from his own experience of ruined walls.'[7]

Turner never travelled to Levant, although it had become, among the cognoscenti, a popular place to visit. His extensive travels were confined to Europe, Switzerland being one of his favourite haunts. He planned his journeys with care, deciding on his route before leaving London and even jotting down in his notebooks some useful phrases in different languages (Fig. 11). He was indeed a professional traveller. Despite his peripatetic nature, however, Turner never crossed over to Ireland, although he did express a wish to go there. Thomas Moore in his *Memoirs* recounts how, having dined with Turner one evening, he mentioned that he thought of asking him to commemorate with his clever pencil, the neighbourhood of Bowood where he, Moore, lived. As he was prevailing upon Turner to make some sketches of the area, Turner interrupted by exclaiming:

'But Ireland, Mr. Moore, Ireland! There's a region connected with your name. Why not illustrate the whole life? I have often longed to go to that country; but am, I confess, afraid to venture myself there. Under the wing of Thomas Moore, however, I should be safe.'

Unfortunately the travelling partnership never did materialise. In the early nineteenth century Ireland was in a state of unrest following the 1798 Uprising - a revolt against British rule in Ireland. The ensuing political upheaval deterred Turner from visiting the country. He channeled his energies into his travels elsewhere. An amusing account of his antics on the journey from Rome to Bologna in 1829 was recounted to Thomas Uwins R.A. by a young Englishman who, though accompanying Turner on this journey, knew nothing of his reputation.

'I have fortunately met a good tempered funny, little, elderly gentleman, who will probably be my travelling companion throughout the journey. He is continually popping his head out of the window to sketch whatever strikes his fancy, and became quite angry because the conductor would not wait for him whilst he took a sunrise view of Macerata. "Damn the fellow!" says he. "He has no feeling". He speaks but a few words of Italian, about as much of French, which two languages he jumbles together most amusingly. His good temper, however, carried him through all his troubles. From his conversation he is evidently near kin to, if not absolutely, an artist. Probably you may know something of him. The name on his trunk is, J.W. or J.M.W. Turner!'.[8]

This first hand account of travelling with Turner provides us with an interesting insight into his character. Although forever at work with his pencil, he appears to have been a pleasant companion, possessed of a sunny disposition and easy manner, unperturbed by his traveller's lack of recognition.

That journey through Italy in 1829 was particularly hazardous. Turner's route led him to cross into France via the Mont Cenis Pass which was particularly dangerous in wintertime. Dr. Boswell, who made the same crossing in 1765, describes how he was carried by porters 'in the Alp machine which consisted of two trees between which were twisted some cords on which (he) sat. The porters were extremely dexterous as they leaped from rock to rock and generally the journey passed without incident.'[9] However, when Turner made

Fig. 12. *Messieurs les voyageurs on their return from Italy (par la diligence) in a snow drift upon mount Tarrar —*
22nd of January, 1829 (Trustees of British Museum, cat. no. 1958 — 7-12-431). Watercolour.

the crossing it was in winter and he had to be
transferred to a sledge owing to the frosty conditions.
This mode of transport, as Thomas Pelham recounts,
'though very trying to the nerves was not unpleasant'.[10]

Once over Mont Cenis, the diligence then capsized in
the snow, forcing the travellers to camp out for three
hours while the coach was righted. Turner later records
this event in a wonderfully evocative watercolour

entitled *Messieurs les voyageurs on their return from Italy (par la diligence) in a snow drift upon mount Tarrar, 22nd of January 1829* (Fig. 12). He has included a self portrait showing himself to the right of the picture, observing the scene slightly aloof from the company.

A solitary man by nature, Turner never developed the easy urbane manner so much associated with nineteenth century gentlemen. Nevertheless, he had many close friends which included fellow academicians such as Sir Francis Chantrey, George Jones, Sir Thomas Lawrence and Sir David Wilkie. Lord Egremont of Petworth, a wealthy eccentric aristocrat, was both patron and friend to Turner, as too was Walter Fawkes of Farnley Hall and H.A.J. Munro of Novar. The latter was one of the few people Turner ever invited to accompany him on a sketching trip abroad. Munro accompanied Turner on his second trip to Switzerland in 1836.

Two sketchbooks, the *Fort Bard* (T.B. CCXCIV) and the *Val d'Aosta* (T.B. CCXCIII), are filled with pencil drawings recording this trip, but no colour sketches from this trip remain in the Turner Bequest sketchbooks. Munro, however, himself reliably informs us that Turner did make colour sketches. He later recounted 'I don't remember colouring coming out till we got into Switzerland'.[11] This is borne out by the two vivid mountain sketches *Tête Noire* (Pl. 21) and *An Alpine pass in the Val d'Aosta* (Pl. 22) in the National Gallery of Ireland's collection which date from this visit.

It is interesting to compare these Alpine scenes with Turner's earlier work, *The Great Fall of the Reichenbach* (Pl. 11), which was executed in 1802. In these two works the conceptual images are built out of broad washes of bright colour. The local colours, with the exception of the black sheer face of *Tête Noire*, become less substantial, and more transparent as they freely intermingle with the aerial colours embodied in the cloudy sky. The majestic mountains are no longer

viewed as fearful threats to mankind but rather as the gentle giants of landscape which appear to stretch up to the heavens. Turner's skies are among the most individual and interesting aspects of his work. Dotted with cloud formation, they are constantly in motion, being exciting, immediate declarations of nature's vast repertoire of patterns. They form a vital part of his pictures. In his late Venetian works, the brilliant skies create a vibrant atmosphere which is continued in the glowing aerial colouring adopted by the structures below.

In *The Doge's Palace and Piazzetta* (Pl. 26), a yellow blue sky rolls out over the vivid aquamarine sea, suffusing the atmosphere with a hazy blue light. The facade of the Doge's Palace glows with a rosy purplish hue which contrasts delicately with the pale violet of the Zecca. Whilst each of these contrasting colours embodies an independent brilliance, Turner has skilfully woven them together into a harmonic unity, making it a scene of breathtaking loveliness. As his experience of nature increased, Turner's concepts of landscape became more increasingly refined. His penetrating observation of the world about him meant he saw in the landscape colours and constructions which were not obvious to all. He responded to these views with passion and fervour which led him to conceive highly complex pictures which are conveyed in intricate, detailed and skilful compositions.

Turner developed a finely tuned intuitive feel for landscape. He was constantly seeking to convey the essence of nature and his response to a scene observed resulted in unique, highly individual landscape views. In 1819, the famous Irish physician Robert Graves (1796-1853) (Fig. 13) met up with Turner in the Alps. The two travelled together for some months taking in a particularly hazardous boat journey from Genoa to Sicily. During a storm, the crew threatened to desert. In order to gain control of the situation, Graves first stove in the boat and then proceeded to mend the

Fig. 13. *Dr. Robert Graves* by Charles Grey (National Gallery of Ireland, cat. no. 3786). Watercolour.

Turner would remain quiet, apparently idling the time away until at some given moment he would exclaim 'There it is!' and, seizing his colours, work rapidly until he had noted down the peculiar effect he wished to fix in his memory.

'I used to work away', Graves said, 'for an hour or more and put down as well as I could every object in the scene before me, copying form and colour, perhaps as faithfully as was possible in the time. When our work was done and we compared drawings, the difference was strange: I assure you there was not a single stroke in Turner's drawing that I could see like nature, not a line nor an object and yet my work was worthless in comparison with his. The whole glory of the scene was there.....'[12]

Turner approached his use of colour from a scientific view point as well as an instinctive one. He was very interested in the harmonic theory of colour which recognised the existence of three primary colours, red, yellow and blue. This theory was elaborated by entomologists Ignaz Schiffermuller in Vienna and Moses Harris in London during the 1780s and 1790s. These two men demonstrated the complementary nature of the three primaries with their three secondary colours: red-green, yellow-violet, blue-orange. They sought to make them the basis of harmonic colour relationships in painting. Turner, along with Delacroix (1798-1863) in France and the German Philipp Otto Runge (1777-1810), author of *Theory on Colour Harmony*, published in 1810, were among the best known artists who became interested in the scheme and applied it to their work.[13] The use of pure or primary colour becomes increasingly evident in Turner's mature works. Yellow, his favourite colour, dominates many of his watercolours, such as *San Giorgio Maggiore* (Pl. 27). Built out of brilliant yellows subtly gradated, the church glows with the vividness of a rising sun casting its rays on the surrounding waters. This watercolour was executed in 1840, but as early as 1826 Turner had

broken pumps with his own boot leather! They both survived and Graves leaves us some interesting accounts of his time spent sketching with Turner. Once they had fixed on a point of view, they would return to the scene day after day. Turner would make one careful outline of the scene and then, while Graves worked on,

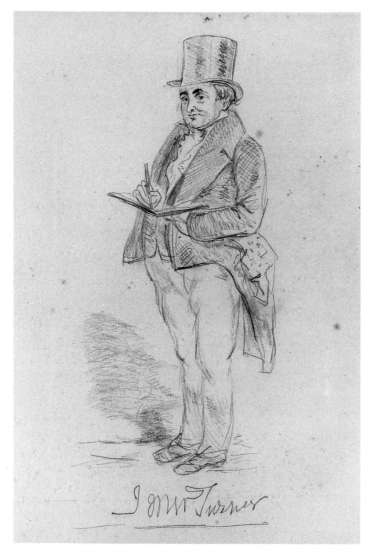

Fig. 14. *J.M.W. Turner* by Charles Martin (National Portrait Gallery, London, cat. no. 1844).

begun to use vivid yellows to tremendous effect. One reviewer of Turner's three oil paintings in the 1826 Royal Academy Exhibition severely criticises his use of yellow: 'In all we find the same intolerable yellow hue pervading everything, whether boats or buildings, water or watermen, houses or horses, all is yellow, yellow, nothing but yellow, violently contrasted with blue....'[14] Despite such criticism, yellow became the hallmark of his art. Yellows, reds and blues, the 'pure' colours, form the bases for his compositions while green as a mixed colour was one which Turner used less frequently in his mature works.

The late continental sketches in the National Gallery of Ireland are wrought in gradations of pure colour. The colours unite the scene into a distinctive whole. In *Passau at the confluence of the Rivers Inn and Danube* (Pl. 30), a highly detailed panoramic view of the German town, the minutiae do not disrupt the harmony of the scene but are interwoven into the overall patchwork pattern which is united by a prevailing bluish atmosphere. These highly coloured detailed scenes, executed in the 1840s, in which so much detail is united into a solid unit, convey a further individualistic perception of nature. Depth, form and colour are successfully woven into brilliant detailed landscape views; such highly complex compositions belie a profound study and knowledge of landscape. For Turner (Fig. 14), nature was his inspiration and colour, his language. As he grew older, his acute observations of the world about him were conveyed through increasingly vivid imagery which, together with his intricate designs, revolutionised painting in the nineteenth century.

1. Ruskin 1851-52, no. 98.
2. Gage 1969, p. 27.
3. Wilton 1975, p. 10.
4. Gage 1969, p. 32.
5. Lionel Cust 'The Portraits of J.M.W. Turner', *Magazine of Art*, (1895) pp. 248-49.
6. Gage 1980, no. 48.
7. Ruskin 1903-12, vol. 13, p. 42.
8. Uwins 1858, vol. 2, pp. 239-40.
9. Hibbert 1986, p. 99.
10. *Ibid.*
11. Finberg 1939, p. 361.
12. Biographical notice contributed by William Stokes, (Regius Professor of Physics in the University of Dublin.) to *Studies in Physiology and Medicine* by Robert James Graves, (London 1863), p. XI.
13. For further reference see Gage 1969, p. 13.
14. Gage 1980, no. 115.

The Henry Vaughan Bequest

Henry Vaughan was among the last in a line of nineteenth century connoisseurs who dedicated their lives and money to the study of art. Their resulting collections, many of which benefited public institutions, consisted of both works by contemporary artists whom they patronised and old masterpieces which were generally bought on travels abroad. Vaughan was born of a Quaker family in Southwark where his father owned an extremely successful hat manufacturing business. On his death in 1828, he left a large fortune to his son, Henry. Henry was educated privately at Walthamstowe where he met the young Benjamin Disraeli, future Prime Minister of England. Disraeli's eccentric schoolboy exploits became legendary and Vaughan was among those who in later life enjoyed recounting his experiences of Disraeli's odd behaviour.

Taking advantage of his large fortune, which he inherited at the age of twenty-one, Vaughan frequently travelled abroad collecting works of art. In London, where he lived at 28 Cumberland Terrace, Regents Park, he led a quiet life devoting his time to his studies.

His collection was somewhat eclectic, favouring works by Italian Renaissance masters as well as contemporary landscape painters. (Lugt 1380) During his lifetime he presented the famous *Hay Wain* by Constable to the National Gallery, London, while in 1887 he presented the British Museum with five important drawings by Michelangelo and three by Raphael.

Vaughan was particularly fond of collecting works by Turner and Constable, but he also owned numerous paintings by other contemporary artists such as Stothard and Flaxman. His collection of Turner watercolours, described in the *Athenaeum Magazine* (December 1899) as being 'singularly choice and indeed hardly paralleled in this country' were all the more remarkable for their excellent condition. Although Vaughan did not frame all his watercolours, he is known to have stored them in portfolios in strong boxes, which protected them from the light. This showed a far-sightedness unusual for his time, as the dangers of light on watercolour were not generally recognised until the publication of the Russell and Abney *Report on the Action of Light on Watercolours* in 1888.

Henry Vaughan was elected a member of the Athenaeum Club in 1849. Turner was also a a member of this Club and it is possible the two men were acquainted. Certainly Ruskin knew of Vaughan. He wrote to his secretary, C.A. Howell, from Interlaken (May 26, 1866),

'All you have done is right except sending Mr. Henry Vaughan about his business.

He is a great Turner man. Please write to him that he would be welcome to see everything of mine, but I would rather show them to him myself...'.[1]

Vaughan was also well acquainted with Thomas Griffith, Turner's agent, and was, along with the two Ruskins, father and son, a favoured customer. Many of the unexhibited watercolours in his collection may have derived from this source. Although of a rather shy modest nature - he would not allow his donation of the *Hay Wain* to be publicly divulged until after his death - Vaughan was one of the founding members of the

Burlington Fine Arts Club and was a constant contributor to its exhibitions. *A ship against the Mew-Stone at the entrance to Plymouth Sound* (National Gallery of Ireland) (Pl. 12) was exhibited there in 1871.

Henry Vaughan died unmarried at the age of ninety-one. In his will he bequeathed his considerable collection of art to public institutions, the main benefactors being The National Gallery, The British Museum, The Victoria and Albert Museum, The University of London, The National Gallery of Scotland and The National Gallery of Ireland. The bulk of his fortune he left to charitable and religious institutions.

As part of the Vaughan Bequest, the National Gallery of Ireland received thirty-one watercolours by Turner. Conscious of the damage of light on watercolour, Vaughan stipulated that the drawings should only be exhibited in January when the sunlight is at its weakest, a condition which is still adhered to today. The provenance of many of these watercolours is unknown. Vaughan bought many of his works privately, as the collectors in London dealt among themselves and many works changed hands in this way. *Beech Trees* (Pl. 2) was purchased from Dr. Monro of Adelphi Terrace and it is probable that Vaughan purchased his *Monro Sketches* (Pls. 3-9) at Dr. Monro's sale at Christie's in 1833. Some other Turner watercolours may have been purchased by Vaughan at the Henry Munro of Novar sale at Christie's in 1877. His name does not appear on the register of sales, but it is possible he acted through Agnew's who bought a number of Turner watercolours that day and from whom Vaughan bought on occasion. Ruskin's correspondence from Interlaken with his secretary C.A. Howell indicates that he too may have helped Vaughan procure some of Turner's works.

Also Thomas Griffith, Turner's agent, had possession of some of Turner's late sketchbooks, one of which he sold to Ruskin. On the *verso* of a sketch, *Study of a Coastal Scene*, Ruskin has written 'Leaf out of a late time sketch book in my possession (bought of Griffity)'. (This sketch was sold at Morrison, McChlery & Co., Glasgow on May 16, 1958, lot 91). The late views of Lake Lucerne in the Dublin collection may have come from the same source, as Ruskin tells us Turner did deposit preliminary sketches of Lake Lucerne with Mr. Griffith on his return from Switzerland in 1841, '42 '43 and '44.

The Vaughan Bequest of watercolours by Turner is described by Andrew Wilton in *Turner in the British Museum* as 'one of the most impressive (collections) ever assembled.' The collection indicates a tasteful scholarly approach to Turner's art, and the watercolours reflect the different stages in Turner's development. The cohesive groups in the collection have remained together. The National Gallery of Scotland retains the watercolours connected with the series of *Picturesque Views in England and Wales* and the illustrations for the *Poetical Works* of Sir Walter Scott. Dublin is fortunate in having the only two early topographical views and also the drawings for one of Turner's first great series of engraved illustrations, *Picturesque Views of the Southern Coast of England.*

Five other watercolours by Turner complete the National Gallery of Ireland's collection of Turner's work. These are *Harlech Castle* from the W. M. Smith Bequest in 1872, *The Grand Canal from below the Rialto Bridge, Venice* and *Bregenz, Lake Constance, Austria* which were left to the nation by Robert Dubthorne Bryce in 1972, and *A View of Wellmich on the Rhine* with a sketch of *Bacharach* on the *verso* from the Miss A. Callwell Bequest in 1904. These are all included in this catalogue.

1. Ruskin 1903-12, vol. 37, p. 688. I am indebted to Ann Forsdyke for pointing out this reference to me.

The cabinet in which the Vaughan Bequest Turner watercolours were presented.

The West Gate, Canterbury, Kent
c.1793 (Pl. 1)

Pencil and watercolour on paper, 27.9 × 20.2 cms.

SIGNED: bottom left, *Turner*

PROVENANCE: Henry Vaughan Bequest, 1900

EXHIBITED: 1887, Royal Academy, London, no. 21.

LITERATURE: Armstrong 1902, p. 245; Finberg 1939, p. 23; Wilton 1979, no. 56.

Cat. no. 2408

The close of the eighteenth century in England saw a reawakened interest in the countryside and its architectural heritage. Together with this interest came a great demand for topographical views, which Turner, among other artists, was ready to supply. From an early age, Turner had painted topographical views which his father is reputed to have sold in his barber's shop on Maiden Lane, London. By the time he had reached his late teens, Turner's reputation as a skilled

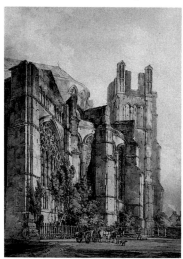

Fig. 15. *St. Anselm's Chapel, Canterbury Cathedral* (Whitworth Art Gallery, cat. no. D.1131892). Watercolour.

Fig. 16. *The West Gate, Canterbury* (T.B. XV-E, Tate Gallery, London). Watercolour.

draughtsman was quite well established and he received commissions from both collectors and engravers for English rural scenes. In the autumn of 1793, during a sketching tour of Kent, Turner visited the city of Canterbury and later that year he produced watercolours of the area based on the sketches he had made there. One such work is *St. Anselm's Chapel with part of Thomas-a-Becket's Crown, Canterbury Cathedral* (Whitworth Institute, Manchester) (Fig. 15) which was exhibited at the Royal Academy in 1794. This watercolour is signed and dated 1793 and it is believed that the Dublin watercolour was done at the same time. However, the Manchester work shows a greater influence of Thomas Malton, to whom Turner had been apprenticed c.1789. *The West Gate, Canterbury* is not as highly finished; the brushwork is looser and the scene a record of daily life rather than a study of medieval architecture. *The West Gate, Canterbury* was never exhibited during Turner's lifetime, which suggests it may have been done as a record for his own

collection. His *Canterbury and Rochester* Sketchbook (T.B. XV E) contains another finished watercolour of *The West Gate, Canterbury* (Fig. 16). The view point is different, however, showing the river Stour in the foreground with the Church of the Holy Cross on the right bank.

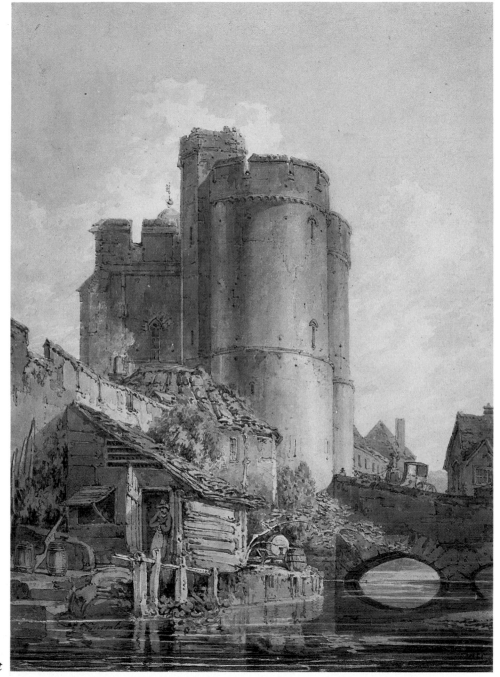

Pl. 1 *The West Gate, Canterbury, Kent*

Beech Trees at Norbury Park, Surrey c.1797 (Pl. 2)

Pencil and watercolour on paper, 44.1 × 43.3 cms.

INSCRIBED: on reverse of mount, *Norbury Park T. 1801.*

PROVENANCE: Dr. Thomas Monro; Henry Vaughan Bequest, 1900

LITERATURE: Armstrong 1902, p. 268: Wilton 1979, no. 155.

Cat. no. 2409

In 1797 Turner visited Norbury Park, Surrey, the seat of sculptor, William Lock. He was commissioned to draw Mr. Lock's fernhouse (exhibited 1798, Royal Academy, coll. untraced). While there he took the opportunity to make some detailed studies of the trees of the area including the great beech trees in Norbury Park, which appear in the above mentioned watercolour. The scene is expressive of the open countryside of Surrey, where the trees, lightly intertwined,stretch out gracefully. The delicate patterns of foliage are rendered in an almost featherlike manner revealing the sensitivity of brushwork which begins to appear in Turner's work about this time.

Another drawing of this subject, possibly done at the same time, is in the Indianapolis Museum of Art (Fig. 17).

Fig. 17. *Beech Trees* (Indianapolis Museum of Art, cat. no. 13,442). Watercolour.

Pl. 2 *Beech Trees at Norbury Park, Surrey*

The 'Monro Academy'

Dr. Thomas Monro (1759-1833) was one of the most noted connoisseurs of his time. A physician by profession, he was attached to the famous Bethlem Hospital for the Insane and treated George III during his illness of 1811-12.

An amateur artist of some merit, Monro studied with the watercolour painter John Laporte (1761-1839) and housed a considerable collection of watercolours and drawings at his residence, 8 Adelphi Terrace. Farington notes in his diary (April 14, 1797) 'the house was full of drawings, in the dining parlour 90 drawings framed and glazed are hanging up and in the drawing room 120. They consist of drawings by Hearne, Barret, Smith, Laporte, Turner, Wheatley, Girtin'. Anxious to promote the art of watercolour painting, Monro was one of those most responsible for the eventual foundation of the Society of Painters in Water-Colour. He also held painting classes in the evening at his house where he paid young artists to make copy watercolours from his collection. This 'Academy' was run like a school, with two pupils to a desk, sharing a candle. Among those artists who passed through this 'Academy' were Turner, Thomas Girtin (1774-1802), J.S. Cotman (1782-1842), Peter de Wint (1784-1849), John Varley (1778-1842) and Louis Francia (1772-1839).

Turner and Thomas Girtin (Fig. 18), whose brilliant career was tragically brief, attended the 'Academy' at the same time between 1794 and 1797. Farington gives us an insight into the arrangement. On November 11, 1798 he notes 'that Turner and Girtin told us they had been employed by Dr. Monro 3 years to draw at his house in the evening. They went at six and stayed till ten. Girtin drew in the outlines and Turner washed in

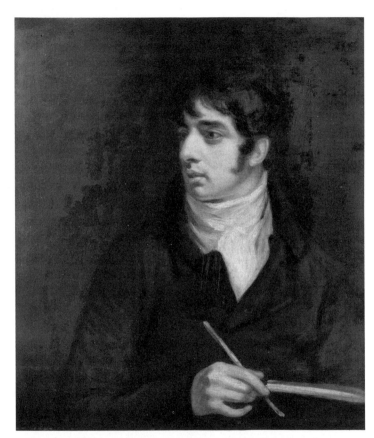

Fig. 18. *Thomas Girtin* by John Opie (National Portrait Gallery, cat. no. 882). Oil.

the effects. They were chiefly employed in copying the outlines or unfinished drawings of Cozens etc. etc. of which copies they made finished drawings. Dr. Monro allowed Turner 3s 6d each night - Girtin did not say what he had'.

It appears Turner had terminated his employment

with Dr. Monro by 1798 when he spoke to Farington. This is not surprising. The academic work was, no doubt, of value to Turner, giving him an insight into methods and technique of other watercolour painters. Nevertheless, applying washed effects to copy drawings was bound to have become tedious; besides, by this time Turner had established quite a reputation as a topographical painter. As he told Farington in October 1798, 'He had more commissions at present than he could execute and got more money than he expended'.

Dr. Monro kept all the drawings done by his pupils and they were put on the market with the rest of his collection after his death in 1833.[1] Over four hundred study drawings in the sale catalogue were attributed to Turner, with only twenty six attributed to Girtin. Judging how Monro ran his 'Academy', this attribution of four hundred drawings to Turner was grossly exaggerated. The students worked together on drawings, and even with Turner and Girtin working together, four hundred drawings is a prodigious output for three winters' work.[2]

By 1833, when Monro's collection was put on the market, Turner had become quite a famous landscape painter and a respected member of the Royal Academy. As the auctioneers perceived, works attributed to him were bound to fetch high prices. Indeed lots attached to his name fetched far higher prices than original works by John Robert Cozens, for example.[3] Turner, ever conscious of his reputation as a painter, was not happy to have such an amount of study work attributed solely to him. At the auction he bought two volumes of Swiss and Italian scenes, amounting to about one hundred and fifty watercolours, so as to withdraw them from circulation altogether. Many of the rest of the drawings remained on the market and appear in other collections. For example there are eleven such 'Monro sketches' in the Henry Vaughan Bequest. Five are in the National Gallery of Scotland and the remaining six are in Dublin. Included also in this catalogue as a 'Monro sketch' is *Harlech Castle*, (Pl. 8) presented by William Smith in 1872 to the National Gallery of Ireland.

These Monro sketches are quite distinctive in style and technique. They are all pencil drawings with blue and grey wash on paper. Sometimes, however, green and ochre was included, for example, in *A river in the Campagna, Rome* (Pl. 9)

As the drawings were done to a formula, ascribing definite authorship to any of them is tentative and so they are catalogued here, collectively, as sketches from the Monro School.

1. Monro sale, Christie's, June 26-28, 1833.
2. It seems logical that Turner worked for Dr. Monro during the winter months only, as he was employed on sketching tours during the summer. For further reference see Henry Angelo, *Reminiscences*, (1904), p. 1.
3. Cozens' reputation had completely faded at this time and he is omitted from a survey of English art published in 1833. See Bell/Girtin 1935.

A View of Velmo near Terni, Italy

1794-97 (after Cozens) (Pl. 3)

Pencil and wash on paper, 24 × 37.3 cms.
PROVENANCE: (?) Dr. Monro; Henry Vaughan Bequest, 1900
Cat. no. 2405

John Robert Cozens (1752-99), an English landscape watercolour artist, active in the late eighteenth century, was a forerunner of nineteenth century Romantic painting. His landscapes, exquisitely executed, with delicate nuances of colour, tend towards intense expression and undoubtedly influenced Turner's style and technique. During 1782 and 1783 Cozens accompanied his patron William Beckford of Fonthill on a journey through Italy. His records of this visit, contained in seven sketchbooks, consist of light rapidly drawn pencil outlines expressing the mood and atmosphere of the Italian landscape. Approximately sixty five 'Monro sketches' attributed to Turner are copies after these drawings. Cozens became a patient of Dr. Monro at the Bethlem Hospital in 1794. It appears Monro then acquired temporary possession of these Italian sketchbooks, which he placed at his students' disposal. This gave Turner an opportunity to make copy sketches from them. The sketchbooks were returned to William Beckford, Cozens' patron, after the latter's death in 1797 and later passed into the Duke of Hamilton's family. Known as the Hamilton Sketchbooks, they were sold at Sotheby's on November 29, 1973 when they were acquired by the Whitworth Institute, University of Manchester.

The above watercolour is a copy after Cozens' sketch of Velmo near Terni. It appears as the first sketch in Vol. VI of these Italian sketchbooks.[1]. As indicated on the original watercolour (Fig. 19), Cozens made this sketch on September 15, 1783, while travelling from Rome to Florence.

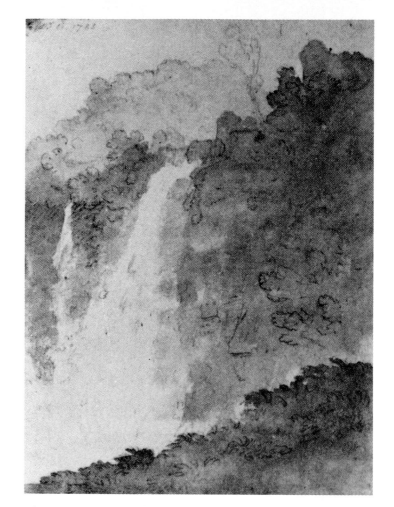

Fig. 19. *A View of Velmo near Terni* by John Robert Cozens (Whitworth Institute, University of Manchester, Hamilton Sketchbooks vol. VI, no. 1).

In the Dublin watercolour, Turner has included two small figures on the ledge to the right. Their diminutive size contrasts sharply with the majestic falls, heightening the drama of the scene.

1. See London 1973.

48

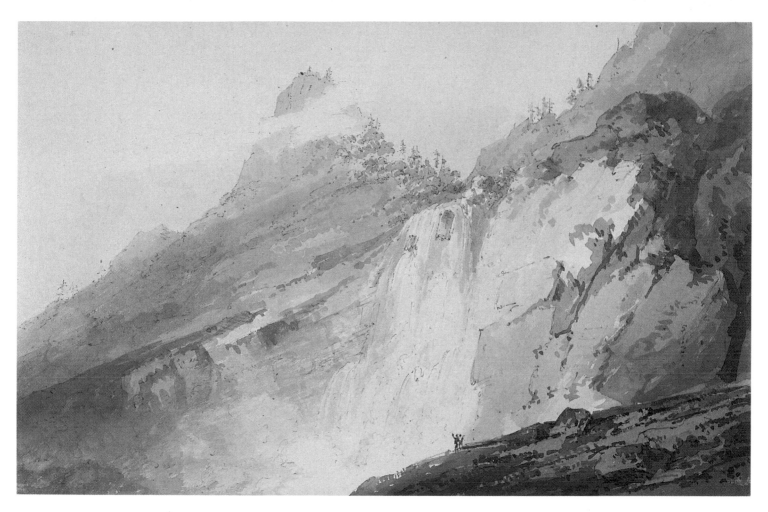

Pl. 3 *A View of Velmo near Terni, Italy*

Sluice Gate, Netley Abbey, Hampshire 1794-97 (Pl. 4)

Pencil and grey wash on paper, 13.6 × 20.6 cms.

WATERMARK: *Whatman*

PROVENANCE: (?) Dr. Monro; Henry Vaughan Bequest, 1900

Cat. no. 2402

This charming sketch is executed in typical 'Monro washes' of blue and grey. Turner has applied the washes in quick lively brushstrokes creating a breezy outdoor atmosphere. The highlights on the running water reveal Turner's delicate skills in watercolour, and his keen perception of nature. In his early career Turner developed this rapid sketching style which he used later to record scenes in his travelling sketchbooks.

Pl. 4 *Sluice Gate, Netley Abbey, Hampshire*

Shakespeare's Cliff, Dover

1794-97 (Pl. 5)

Pencil and wash on wove paper, 20.5 × 27 cms.

PROVENANCE: (?) Dr. Monro; Henry Vaughan Bequest, 1900

LITERATURE: Armstrong 1902, p. 249.

Cat. no. 2406

Throughout his life, the continuous movement of the sea and sky fascinated Turner. He painted these two sublime elements of nature in their varying moods and tempers. In this sketch, although the sea is calm, a certain feeling of unrest prevails, conveyed by the cloudy skies which tumble down onto the low horizon. Later, in 1811, Turner made extensive drawings of the sea for his series of illustrations for *Picturesque Views of the Southern Coast of England.*

Pl. 5 *Shakespeare's Cliff, Dover*

The Waterfront of Old Dover Harbour 1794-97 (Pl. 6)

Pencil and wash on wove paper, 22.6 × 28.3 cms.

WATERMARK: *J. Whatman*

PROVENANCE: (?) Dr. Monro; Henry Vaughan Bequest, 1900

LITERATURE: Armstrong 1902, p. 249; Finberg 1939, p. 37.

Cat. no. 2407

There are approximately one hundred drawings of shipping subjects at Dover and Folkestone attributed to Turner which betray a strong influence of the style of Edward Dayes (1763-1804). Dr. Monro did have a collection of Dayes' works and most probably allowed his pupils to copy from them. The watercolours of Old Dover Harbour in the Vaughan Bequest at Dublin are two such examples. They are study pieces and convey pleasant scenes of coastal life.

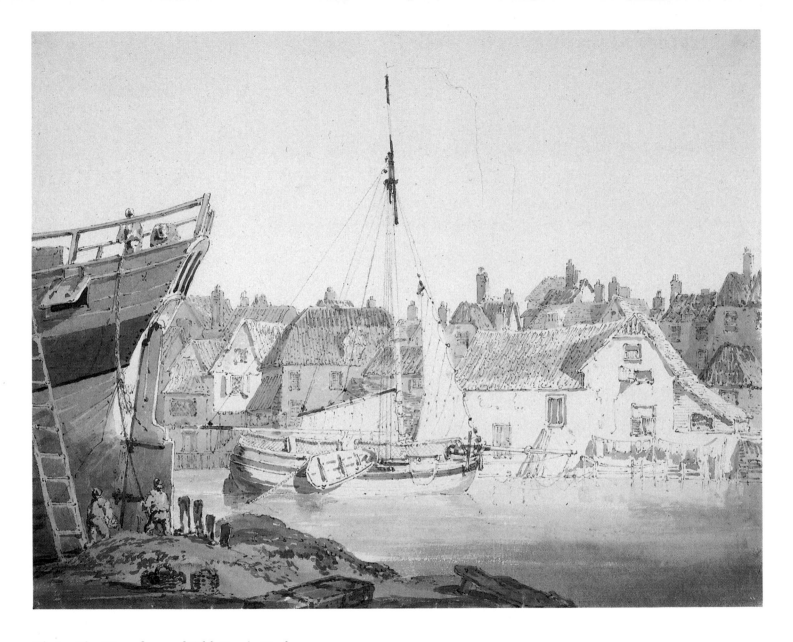

Pl. 6 *The Waterfront of Old Dover Harbour*

Old Dover Harbour, Kent 1794-97 (Pl. 7)

Pencil with blue and grey washes on paper, 23.1 × 34.3 cms.

INSCRIBED: upper margin, *The Shakespere Cliff*

PROVENANCE: (?) Dr. Monro; Henry Vaughan Bequest, 1900

LITERATURE: Armstrong 1902, p. 249.

Cat. no. 2404

Having spent most of his early life near the Thames Estuary, Turner grew familiar with the commercial life on the river. Later, boats and ships were the inspiration for some of his finest works. This great shipping port was extremely active in the nineteenth century as it continues to be so today. It was one of the major seafaring commercial centres on the southern coast of England. Being the nearest point to France, its ferry route to Calais was much travelled. Turner himself sailed from Dover to Calais in 1802, on his first trip abroad.

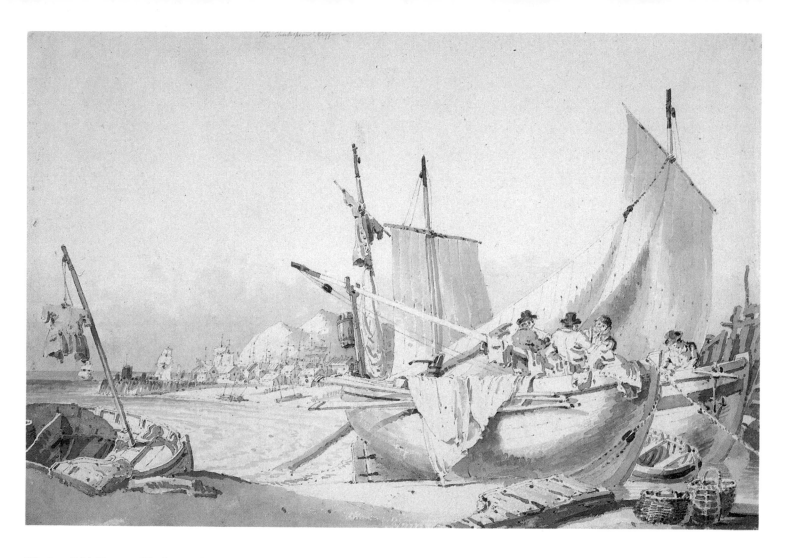

Pl. 7 *Old Dover Harbour, Kent*

Harlech Castle 1794-97 (Pl. 8)

Pencil with blue and grey washes on paper, 26.3 × 37 cms.
PROVENANCE: (?) Dr. Monro; Henry Vaughan Bequest, 1900
LITERATURE: Armstrong 1902, p. 257.

Cat. no. 2284

Turner painted two views of Harlech Castle, one of which is the beautiful oil painting commissioned by the Earl of Cowper and exhibited at the Royal Academy in 1799 (B/J 9).

The other is a watercolour commissioned by Charles Heath as an illustration for *Picturesque Views in England and Wales* (Fig. 20). The viewpoint in that watercolour is similar to the Dublin work with the castle in centre foreground overlooking the Bay of Cardigan. However, the washes in the Dublin work are quite faded and it is now difficult to perceive in it any great input by Turner.

Fig. 20. *Harlech Castle,* 1836 (Engraving by W.R. Smith after Turner, ill. for *Picturesque Views in England and Wales)*

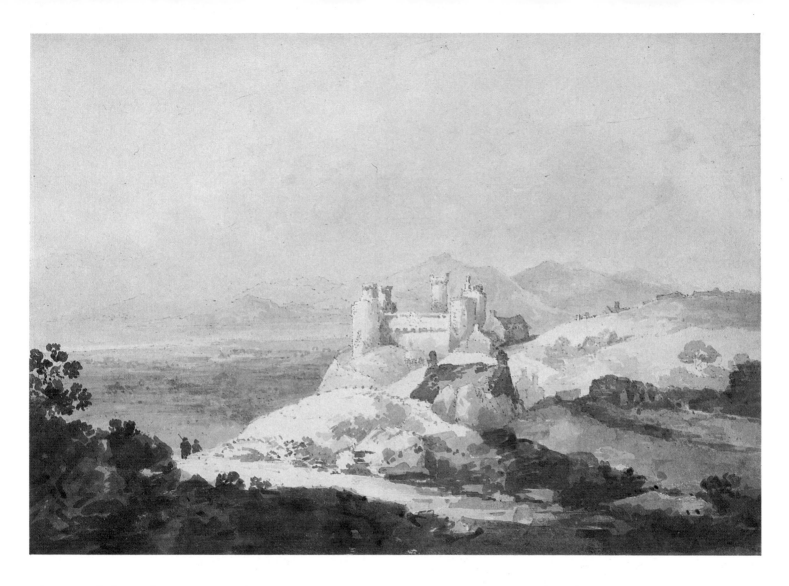

Pl. 8 *Harlech Castle*

A river in the Campagna, Rome

1794-97 (Pl. 9)

Watercolour on wove paper, 15.5 × 25.8 cms.
PROVENANCE: (?) Dr. Monro; Henry Vaughan Bequest, 1900
Cat. no. 2403

Turner did not visit Rome until 1819 when he took a studio there for the winter months. Although most of the Monro sketches are coloured with blue and grey wash, some, like this watercolour, included some green and ochre.

The flat classical landscape in the manner of Claude may be a copy after a drawing by Thomas Hearne. Farington notes that Monro's friends Henderson and Hearne lent him their outlines so that the pupils could copy from them during their evening classes at Monro's house.

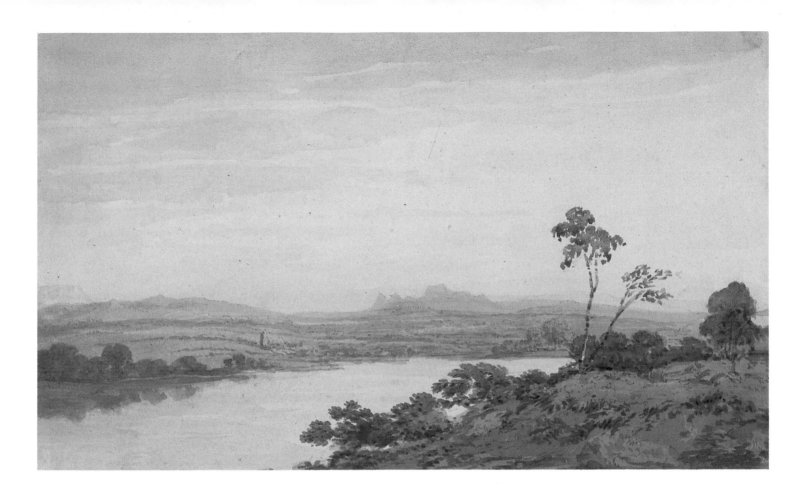

Pl. 9 *A river in the Campagna, Rome*

Edinburgh from below Arthur's Seat 1801 (Pl. 10)

Pencil and watercolour on paper, 25.8 × 41.1 cms.

PROVENANCE: Henry Vaughan Bequest, 1900

LITERATURE: Armstrong 1902, p. 251; Wilton 1979, no. 320.

Cat. no. 2410

Turner set out on his first tour of Scotland in the summer of 1801. He told Farington on June 19 that he was going to Scotland 'on the morrow, on a tour of three months, with a Mr. Smith of Gower Street'. Judging from the drawings in the *Smaller Fonthill* sketchbook (T.B. XLVIII), Turner travelled through the North of England on his way to Scotland, where he stayed in Edinburgh for a few days. The area he covered, mostly on foot, as was his custom, and the speed at which he worked, can be judged from an inscription on the end cover of his *Scotch Lakes* sketchbook (T.B. LVI). '18 July left Edinburgh and on

Fig. 21. *Durham Castle* (National Galleries of Scotland, cat. no. D(N.G.) 889). Watercolour.

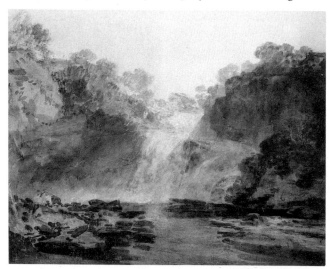

Fig. 22. *The Falls of Clyde* (National Galleries of Scotland, cat. no. D (N.G.) 886). Watercolour.

5 August finished this book at Gretna Green'. In just three weeks he had travelled as far north as Blair Atholl, about thirty miles north of Perth, then west as far as Inveraray on Lough Fyne before heading south to Gretna Green, making almost two hundred sketches in the process.

These Scottish watercolours show Turner's progression away from topographical preciseness

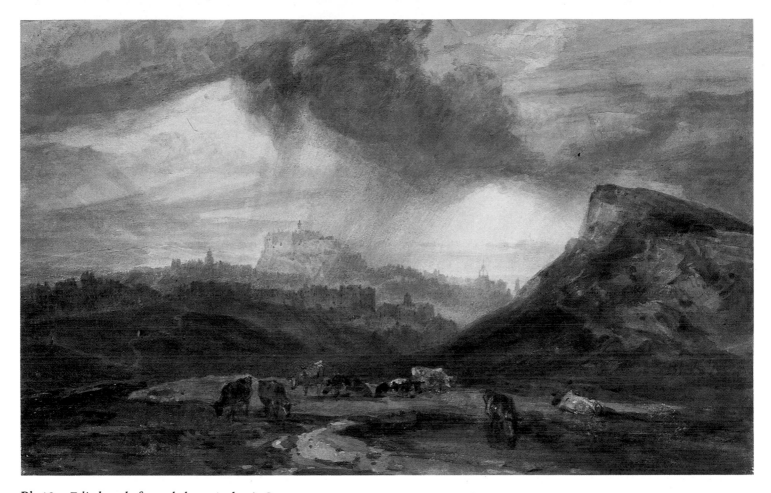

Pl. 10 *Edinburgh from below Arthur's Seat*

towards greater expression in colour. The forms are built up in subdued colour harmonies which express the overall atmosphere of the scene. This Edinburgh watercolour projects a sense of foreboding. Heavily laden storm clouds sweep down diagonally towards the castle, threatening to engulf it, while the cows in the foreground continue to graze, unaware of the impending deluge. Farington tells us (October 1, 1802) that Turner remarked upon his return from France and Switzerland in 1802 that 'the buildings of Lyons are better than these of Edinburgh but there is nothing so good as Edinburgh Castle...'

Edinburgh from below Arthur's Seat (Pl. 10) is a page from the *Smaller Fonthill* sketchbook (T.B. XLVIII). Two other leaves from this sketchbook are in the Vaughan Bequest at the National Gallery of Scotland - *Durham Castle* and the *Falls of Clyde* (Figs. 21 and 22). Like the Dublin work, the low colour key used in these two drawings is more of an expression of the mood of the work, rather than a description of the scene beheld.

The Great Fall of the Reichenbach, Switzerland 1802 (Pl. 11)

Pencil and watercolour over a grey wash on paper,
47.2 × 31.1 cms.

SIGNED: in pencil on the border, *JMW Turner RA Reichenbach*

PROVENANCE: Henry Vaughan Bequest, 1900

LITERATURE: Armstrong 1902, p. 272; Wilton 1976, p. 65; Wilton 1979, no. 361

Cat. no. 2431

In 1802, the Napoleonic Wars came to a temporary cessation with the Peace of Amiens. Turner took advantage of this brief respite to make his first visit to the continent.

On July 15, 1802, he left London for Dover where he set sail for Calais. Apart from spending some time in Paris, making frequent visits to the Louvre, Turner did not delay too long in France. He travelled from Paris down to Lyon where he spent three days. As he told Farington on his return, he found the buildings there interesting. Yet, as his sketchbooks testify, he did not make many drawings of the area. From Lyon he crossed over to Switzerland via Grenoble and Chambery. By the time he returned to Paris in late September, Turner had made an extensive tour of the Swiss Alps and neighbouring areas, travelling as far south as the Val d'Aosta.

In Paris, on September 30, he met Joseph Farington at the Louvre. Farington recounts how Turner talked freely about his impressions of Switzerland. 'He thought the lines of the Landscape features rather broken,.. but there are very many fine parts - fragments and precipices very romantic and strikingly grand ... The Country on the whole surpasses Wales and Scotland too'.

Turner found the majestic Alpine scenery much to his liking. The towering mountain peaks and plunging chasms, awesome to behold, were ideal subject matter for Romantic landscape painting. The nineteenth century saw a growing interest in the concept of the 'Romantic' or 'Sublime'. In 1757, the publication of Edmund Burke's treatise *Philosophical Enquiry into Our Ideas on The Sublime and The Beautiful* taught that noble art is that which excites fear and wonder in those who behold it. Burke expressed it thus:

'Whatever is fitted in a sort to excite the ideas of pain and danger, that is to say, whatever is in any sort terrible or conversant about terrible objects, or operates in a manner analogous to terror is a source of the sublime, that is, it is productive of the strongest emotion which the mind is capable of feeling'.

Eighteenth century landscape painting saw man in control of his environment. Nature's wilfulness was tamed into submission and its noble beauty expressed through gracious depictions of rolling pasturelands, deer parks and formal gardens. Following on Burke's treatise, the Romantic art of the nineteenth century was inspired by the wild, terrifying and ultimately 'grand' aspects of nature which remained outside man's control.

Thus the majestic Alpine scenery was attractive to the painters of the 'Sublime'. Turner found its spectacular views, such as *The Great Fall of the Reichenbach*, ideal subject matter for his work.

This view of the *The Great Fall of the Reichenbach* depicts a mighty torrent of water which tumbles relentlessly down the mountainside, sparing nothing in its path. Only the huge boulders flanking the waterfall are capable of withstanding the force. To the left, the two figures standing on the ledge not only emphasise

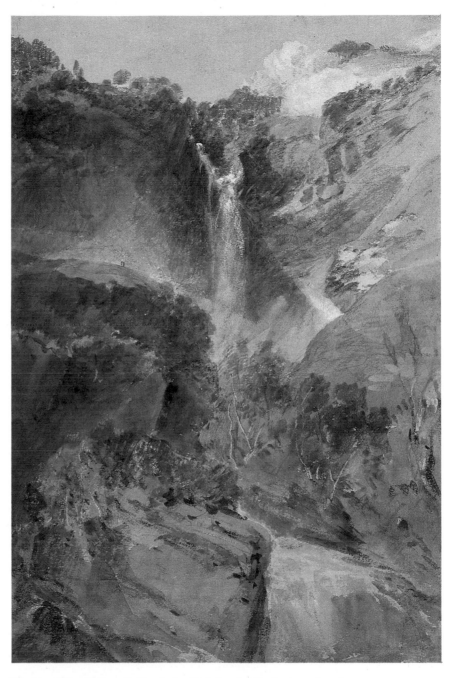

Pl. 11 *The Great Fall of the Reichenbach, Switzerland*

the magnitude of the Fall, but also underline man's frailty when pitted against the might of nature.

The colouring is subdued, echoing the mood of the drawing.In places, Turner has scored right through the paper with his thumbnail, releasing flecks of brilliant white. Fingerprints can be seen in the centre and along the right hand side of the page, indicating where Turner has used his fingers to blend the colours together, a common occurrence in his watercolours.

This study of the *The Great Fall of the Reichenbach* is a dispersed page from the *St. Gotthard and Mont Blanc* sketchbook (T.B. LXXV), one of the five notebooks Turner took with him on his first continental journey. It is a complete statement in itself. Turner felt no need to reinterpret the scene when two years later he executed a large scale watercolour of *The Great Fall of the Reichenbach* for his patron, Walter Fawkes (Fig. 23).

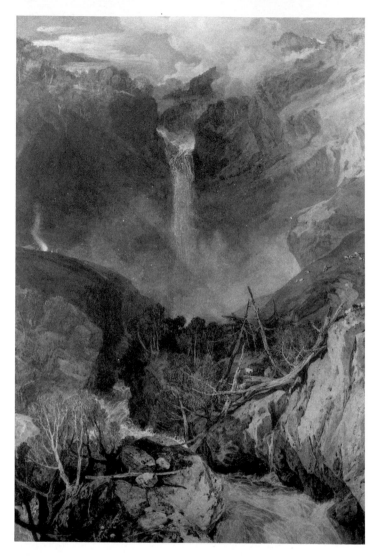

Fig. 23. *The Great Fall of the Reichenbach in the valley of Hasli, Switzerland* (Cecil Higgins Museum, Bedford, cat. no. P.98). Watercolour.

Picturesque Views of the Southern Coast of England, 1814-1826

In the introduction to William Daniell's publication *Voyage round Great Britain* (1814), we are told that 'while the inland counties of England have been hackneyed by travellers and quartos, the coast has hitherto been most unaccountably neglected and if we except a few fashionable watering places is entirely unknown to the public'. Realising this, William Bernard Cooke, an experienced line engraver, together with his brother George, decided to issue a series of plates depicting scenes from the south coast of England. The publication was entitled *Picturesque Views of the Southern Coast of England*. It included views between Whitstable on the east coast and Watchet on the Bristol Channel in the west. The views were issued in sixteen parts with each part containing three plates and two vignettes. A descriptive letterpress accompanied each view. The series was published by John Murray and J. & A. Arch, who, with others, formed a syndicate to finance the project.

In 1811, Turner received a commission to provide twenty four drawings for *Southern Coast*. This was the first major composition that Turner received from a publisher. It also gave him a splendid opportunity to make a detailed study of coastal life in the south of England. His ensuing designs, carried out on small sheets of paper measuring approximately 15 × 23 cms, proved to be the most complex and intricate compositions he had produced to date. Turner responded warmly to the coastal people and sympathised with their constant exposure to the perils of the sea. Though his views convey the ordinary life of the people, through his evocative compositions, skilfully rendered, Turner imbues his subjects with a sense of the heroic. The National Gallery of Ireland has in its collection two watercolours which were included in this publication, *A ship against the Mew-Stone, at the entrance to Plymouth Sound* (Pl. 12) and *Clovelly Bay, N. Devon* (Pl. 13). W.B. Cooke had originally planned to entrust the remaining twenty five subjects for *Southern Coast* to other more veteran topographers. But when the first four issues were published, the superiority of Turner's designs became obvious. The rival publication, *Voyage round Great Britain*, published by William Daniell, was issued in colour and Cooke realised that in order to compete successfully with it, as his plates were in monochrome, he would have to rely on Turner's highly original designs. Thus Turner was commissioned to execute a further sixteen drawings, making it a total of forty watercolours for *Southern Coast*. The other artists commissioned by Cooke were William Havell, Peter de Wint, William Westall, Henry Edridge, William Alexander, Samuel Owen and Joshua Cristall. In the end they supplied just nine subjects. Originally, it was intended to issue the parts quarterly. After the first few issues were published, however, the remainder appeared sporadically with the final part being published in May 1826. Most of the watercolours were engraved by the Cooke brothers. But as time went on, due to mismanagement, they could not cope with all their work. In order to finish *Picturesque Views of the Southern Coast of England* they were forced to bring in other engravers to help with the publication.

Unlike most artists who provided watercolour work for engraving, Turner worked closely with the engravers. He insisted on seeing the engravers' trial proofs which he corrected when necessary. Turner realised that through these engravings his work would become known to a wider audience and so it was important to him that the plates were of a high

standard. A typical example of his correspondence with Cooke went as follows:

'Dear Sir
 I shall not be in town again before next
 Thursday. If you can send the proof to
 Sandycombe - I can touch it: but
 otherwise it can be left at Queen Ann St
 on Wednesday next and you may have it again
 on Friday morning.

 Yours truly,
 J.M.W. Turner'.[1]

As well as supplying the watercolours for *Southern Coast*, Turner also appears to have had an idea of supplying the letterpress. In his *Devonshire Coast* sketchbook (T. B. CXXIII) there are many pages of descriptive rhyme, describing the places he visited along the coast. It is quite unintelligible, but although the transcripts are written without care and are full of absurd misreadings, confirming the opinion that he was quite a hopeless poet, they do display a sympathy and understanding of the ordinary people, their lifestyle and their constant exposure to the dangers of the seas.

During the publication of *Southern Coast*, Turner's relationship with the Cooke brothers deteriorated. By the time *Southern Coast* had been completed in 1826, they had quarrelled furiously over payments due. After that Turner was to dispense with their services altogether. Nevertheless, the publication was a success. *Picturesque Views of the Southern Coast of England* was reprinted in 1849 by Nattali entitled *Antiquarian and Picturesque Tour round the Southern Coast* (2 vols). In 1892 it was again published by Virtue & Co. with an introduction by Marcus B. Huish.

1. Gage 1980, no. 92.

A ship against the Mew Stone, at the entrance to Plymouth Sound,

c. 1814 (Pl. 12)

Watercolour on paper, 15.1 × 23.2 cms.

PROVENANCE: C. Stokes; E. Rodgett; sale, Christies, May 14, 1859, bt. Agnew; Henry Vaughan Bequest, 1900.

EXHIBITED: 1824, Cooke Gallery, no. 32; 1857, *Art Treasures of the United Kingdom Drawings and Watercolours*, Manchester, no. 325; 1871, Burlington Fine Arts Club, London.

ENGRAVED: 1815, W.B. Cooke for *Picturesque Views of the Southern Coast of England* (1814-26).

LITERATURE: Thornbury 1862, p. 541; Armstrong 1902, p. 266; Rawlinson 1908, no. 97; Wilton 1979, no. 454; Shanes 1981, no. 24.

Cat. no. 2413

Fig. 24. Colour beginning of *A ship against the Mew Stone, at the entrance to Plymouth Sound* (Pl. 12). (T.B. CXCVI-F, Tate Gallery, London).

Plymouth Sound is reputed to be the most beautiful estuary on the English coast. To the east near Wembury Point is the dreaded Mew Stone, a sailor's nightmare, being responsible for many a wreck. These shipwrecks were at one time considered providential. The letterpress accompanying this view in *Picturesque Views of the Southern Coast of England* tells of a traveller arriving at a village on the sound. Finding all the inhabitants down at the beach, he went to investigate. They were busy pillaging a wrecked ship that had been washed up on shore, careless of the plight of the survivors. Appalled, the traveller went in search of the clergyman whom he found standing on a rock holding a lantern on high, in an attempt to lure other ships to the same fate!

During August 1813, Turner made a trip to the West Country in search of material for the *Southern Coast*. He based himself in Plymouth, staying with different friends including the journalist Cyrus Redding. Redding recounts a memorable boat journey he made with Turner to Burgh Island in Bigbury Bay. In order to reach the island it was necessary to sail past the Mew Stone. The journey was extremely rough with high seas running. While other members of the party were violently sick, Turner remained unperturbed, delighting in the spectacle. Redding observed that Turner was an excellent sailor and he studied the movement of the waves with intense concentration muttering 'that's fine - fine!' When they finally arrived at the island, Turner wasted no time in making sketches.[1]

This watercolour attracted much attention by its turbulent seas and stormy sky. Thornbury tells us that Mr. Stokes, the original owner, was struck by the strange weird clouds which introduced a demonic air and 'asked Turner if he did not mean them for the demons and angels of the storm.' Turner confessed the intention.

The hazardous life of the sailor is dramatically

conveyed in this watercolour. The merchantman appears fragile and vulnerable as it sails by the threatening Mew Stone. However it is no longer in danger. The top sails have been reefed so as to reduce the ship's exposure to the strong wind and it is sailing into the calmer waters of the sound.

A ship against the Mew-Stone appeared in Part VI of the original publication of *Southern Coast*.

A colour beginning of this subject appears in one of Turner's sketchbooks (T.B. CXCVI-F). (Fig. 24).

This slight sketch conveys a fundamental arrangement of colour masses, which in the finished work culminate into turbulent skies above the stormy sea.

Turner used this subject of a ship against the Mew Stone again for one of the plates in his *Little Liber* series (Rawlinson 1908, no. 804)

1. Cyrus Redding, 'The late Joseph Mallord William Turner', *The Gentleman's Magazine,* (February 1853), p. 152 (as quoted in Shanes 1981, no. 24).

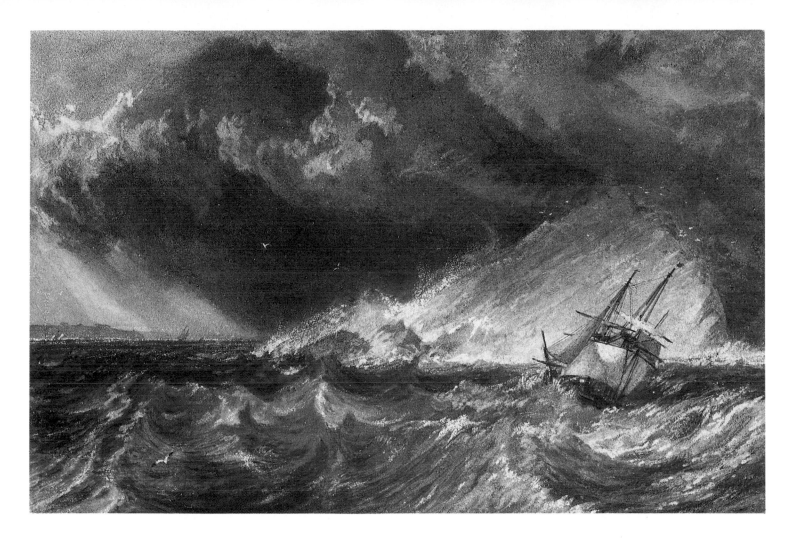

Pl. 12 *A ship against the Mew Stone, at the entrance to Plymouth Sound*

Clovelly Bay, N. Devon c.1822 (Pl. 13)

Pencil and watercolour on paper, 14.6 × 22.5 cms.

WATERMARK: *J. Whatman Turkey Mills*

PROVENANCE: Henry Vaughan Bequest, 1900

ENGRAVED: 1824, William Miller for *Picturesque Views of the Southern Coast of England* (1814-26)

LITERATURE:Armstrong 1902, p. 246; Rawlinson 1908, no. 115; Wilton 1979, no. 472; Shanes 1981, no. 38.

Cat. no. 2414

Clovelly town has been described as a picture hanging over a cliff. In this view it can be seen perched on the cliff edge, to the far left of the painting. The main street consists of a flight of hazardous steps which end in a little pier, making the town totally inaccessible for vehicular traffic. This is why donkeys and mules with laden panniers play such a prominent role in any representation of Clovelly and the surrounding neighbourhood. Here, Turner portrays the shores of

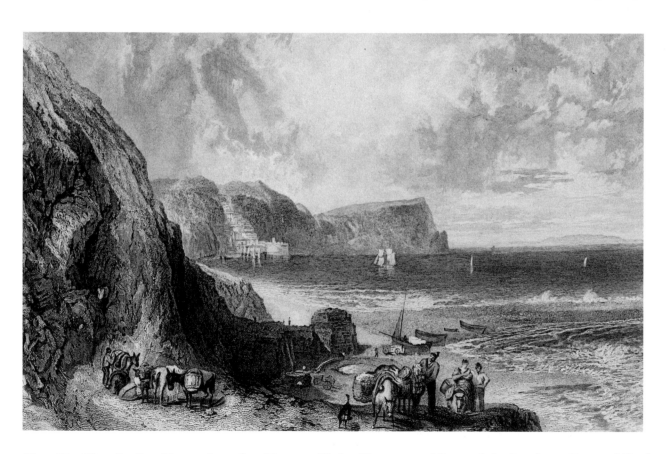

Fig. 25. *Clovelly Bay* (Engraving after Turner, ill. in *Picturesque Views of the Southern Coast of England*).

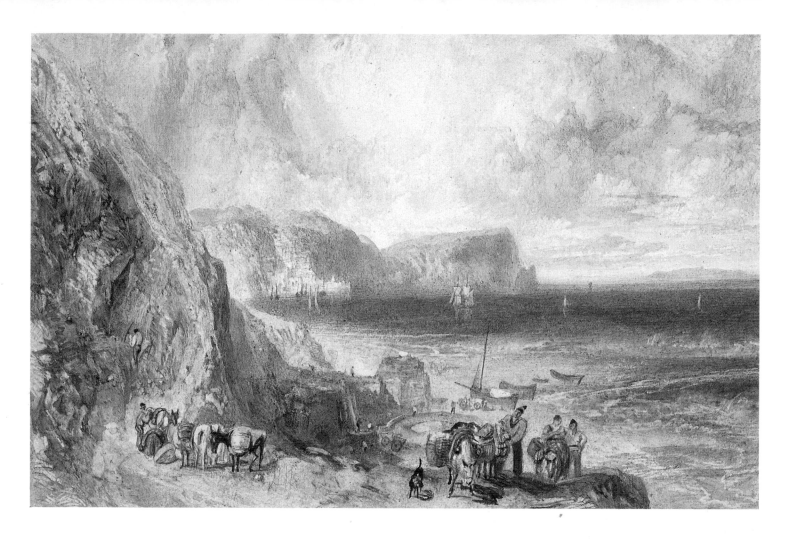

Pl. 13 *Clovelly Bay, N. Devon*

Bucks Mills just down the coast from Clovelly. Boats are drawn up on the rocky foreshore known as the Gore and their cargoes of limestone are unloaded. The limestone is taken away to be burnt in the kilns on the beach. Burning limestone was a common practice on the beachs of North Devon, as the burnt lime was used by farmers to neutralise the acidic soil. The mouth of the western kiln can be seen in the centre of the drawing, in front of the anchored vessels. The donkeys and mules in the foreground are employed to carry the lime up the steep rocky path to the road.

In the distance is Lundy Island, a haven for gannets and puffins. Formerly it was the home of a pirate family, known as the Moriscos. The founder of the family, according to legend, sought refuge there after making an attempt on the life of Henry III. It is a peaceful scene of everyday life on the coast. Turner's calm skies dotted with clouds which float over the deep blue sea convey that warm still atmosphere which is indicative of a hot afternoon in high summer.

This view was illustrated in *Picturesque Views of the Southern Coast of England*. As with all engravings of his work, Turner took great care to correct the trial proofs himself. In the margin of the trial proof of this watercolour (British Museum, London) Turner has written:

'Mr. Miller, soften down the edge of your clouds generally between the shadows and half tones and as a word of advice aim at softness or unity of the tones a little more. The rocky bank above and east side of the town and to the point × thick wood down to the edge of (shelving or shading) lines, below all to the sea. Town and foreground being the only places to land at: Lundy Island too high: make the lights in the clouds (scratched out) brilliant. Sir I must request you to send me an etching and two India and two plain proofs (my compliment from Mr. Engr.) and let me have them when it suits your convenience. J.M.W.T.'

The engravings for *Southern Coast* on India paper were published in a limited edition of five hundred copies. As Turner indicates in his notes to the engraver, Mr. Miller, he believed he was entitled to two India paper engravings of each of his works as part of the contract. W.B. Cooke was reluctant to comply with Turner's demands. As a result the two ended by quarrelling violently, with Turner threatening to bring out a rival publication. Later after *Southern Coast* was finally completed, Turner was to dispense with Cooke's services altogether. *Clovelly Bay* appeared in Part XII of *Southern Coast* (Fig. 25).

Turner and the Sea

During the 1820s, Turner was engaged on two series of watercolours, one for *Rivers of England* (1823-24) and the other for *Ports of England* (1823-28). As he had been brought up in London near the Thames, Turner acquired an early interest in the water and a fascination with the commercial life which sailed upon it. *Fishermen at Sea* (Tate Gallery, London)(B/J 1) was the first oil painting Turner exhibited at the Royal Academy in 1796, although he did not have the opportunity to study the nature of the sea at first hand until he paid a visit to the south coast in 1811. The capricious nature of the ocean, as with mountainous scenery, provided ideal subject matter through which Turner could express the 'Romantic' or 'Sublime' in nature.

Many of his seascapes present sailors in the shipping vessels battling for a supremacy with the wanton power of the sea. The men are constantly exposed to the perils of the ocean, their fate depending on the strength of the vessels. All too often these shipping vessels come to grief on the high seas or against shoreline reefs. Turner, a good sailor himself, has sympathy with sailors and fishermen whose livelihood depended on the water. Their uneasy, but vital, relationship with the sea provides the tension and drama in many of Turner's finest seascapes.

One of his later oil paintings, exhibited in 1842, records a storm at sea during which Turner is believed to have had himself lashed to the mast of a ship. He recounted the incident to Rev. William Kingsley saying he was lashed to the mast for four hours and did not expect to survive, but he felt bound to record the scene if he did.[1] *Snow Storm - Steam Boat off a Harbour's Mouth making Signals in Shallow Water, and going by the Lead. The Author was in this Storm on the Night the Ariel left Harwick* was painted as a result of his experiences (Tate Gallery, London)(B/J 398).

1. Ruskin 1903-12, vol. 5, ch. 12, p. 346.

Shipping c. 1827 (Pl.14)

Pencil on paper, 17 × 22.4cms.

SIGNED: bottom right, *J M W T*

WATERMARK: *J. Whatman 1827*

PROVENANCE: Henry Vaughan Bequest, 1900

LITERATURE: Edinburgh, National Galleries of Scotland, cat. 1980, p. 14.

Cat. no. 2401

Ruskin mentions how he found large numbers of drawings of Dutch shipping in portfolios after Turner's death. This quantity of drawings, together with the models of ships Turner kept in his studio, testify to a huge interest in sea and shipping.

 This drawing may have been a preparatory sketch for the *Ports of England* series 1823-28.[1] Views of Sheerness, Ramsgate and Portsmouth in particular include a man of war and a sloop in much the same composition as in this drawing. However this drawing is a comparatively finished work, and, as it is signed, suggests that it was sold during Turner's lifetime. Another drawing similar to the Dublin work is in the Vaughan Bequest at the National Gallery of Scotland.(Fig. 26) The Scottish drawing shows a man of war in much the same position as the ship to the right in the view of Sheerness.

 1. Only six of the original designs for *Ports of England* were published. After Turner's death they were re-issued with the remaining six views as *The Harbours of England* in 1856.

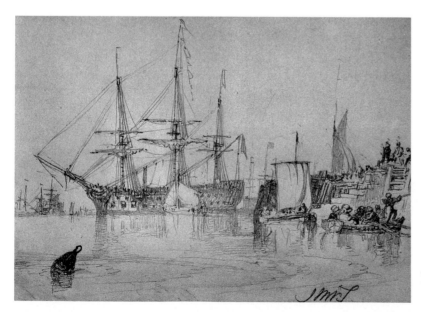

Fig. 26. *Man of War* (National Galleries of Scotland, cat. no. D (N.G.) 852). Pencil.

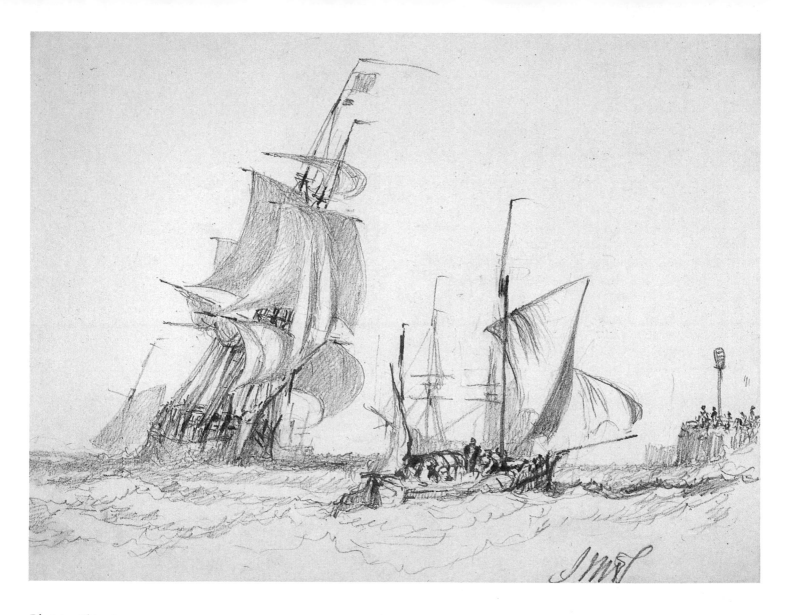

Pl. 14 *Shipping*

A ship off Hastings c. 1820 (Pl. 15)

Watercolour on paper, 20.3 × 26 cms.

WATERMARK: *Whatman 1794*

INSCRIBED: on mount, *Coast Scene - Hastings - from the sea. Commencement of Drawings in Portfolio.*

PROVENANCE: Henry Vaughan Bequest, 1900

EXHIBITED: 1822, Cooke Gallery, London, no. 9.

LITERATURE: Wilton 1979, no. 763.

Cat. no. 2412

This watercolour may have been done by Turner while he was gathering material for the *Ports of England* series.

Turner builds up the view in broad washes of pale colour, through which the cliffs in the backgtround are barely discernible. Sky and sea merge together as they close over the small fishing boat.

This drawing is similar in composition and style to *Shakespeare Cliff, Dover* (Fitzwilliam Museum, Cambridge)(Fig. 27) which Andrew Wilton suggests is a leaf from the *Ports of England* sketchbook (T.B. CCII). The same treatment of the sea and sky also occurs in the colour study for the *Mew Stone* (Fig. 24).

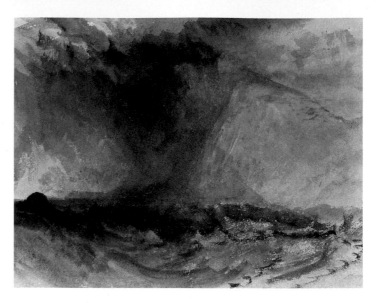

Fig. 27. *Shakespeare Cliff, Dover* (Fitzwilliam Museum, Cambridge, cat. no. PD. 114-1950). Watercolour.

Pl. 15 *A ship off Hastings*

A shipwreck off Hastings c.1828 (Pl. 16)

Watercolour on paper, 18.5 × 28.5 cms.

INSCRIBED: on back, *The Shipwreck or Fairlight Cliff near Hastings from the sea. Drawing belongs to H. Vaughan.*

WATERMARK: *J. Whatman: Turkey Mill*

PROVENANCE: Henry Vaughan Bequest, 1900

EXHIBITED: 1857, *Art Treasures of the United Kingdom*; *Drawings and Watercolours*, Manchester, no. 332; 1891, Royal Academy, London, no. 88.

ENGRAVED: 1866, William Miller.

LITERATURE: Armstrong 1902, p. 257; Wilton 1979, no. 511 and p. 179.

Cat. no. 2411

The futility of man's strength when pitted against the might of the sea is summed up in this spectacular shipwreck scene. Although painting on a small scale, Turner skilfully succeeds in conveying a monumental event.

The fishing boat has capsized and the fishermen are desperately clinging on to the upturned vessel. One unfortunate sailor has been cast adrift and is mercilessly tossed about the turbulent seas. The sheer cliffs behind offer no hope of rescue. They are as impervious to the buffeting waves, as they are to the men's hope of survival.

This watercolour was engraved by William Miller in 1866 and appears as one of the 120 engravings included in *The Turner Gallery*, published in 1878.

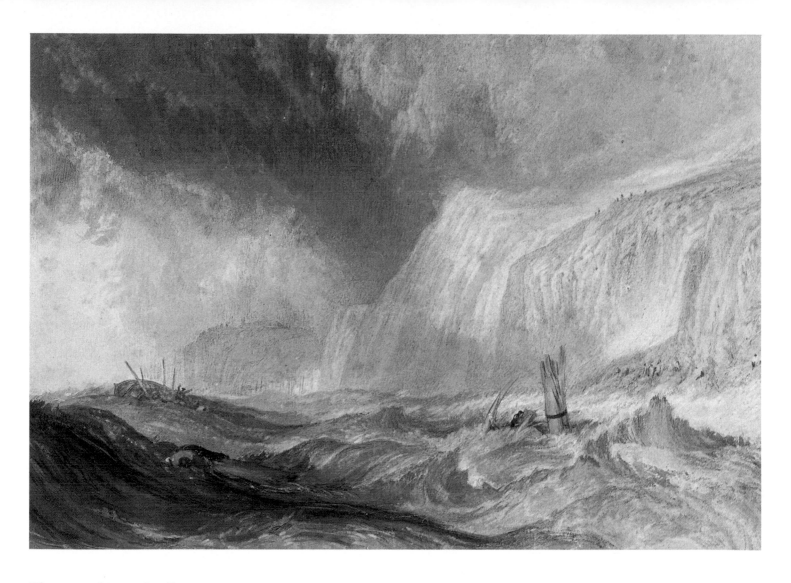

Pl. 16 *A shipwreck off Hastings*

Fishing Boats on Folkestone Beach, Kent, c. 1830 (Pl. 17)

Pencil and watercolour on paper, 18.1 × 25.9 cms.

SIGNED: bottom left, *Turner*

PROVENANCE: Henry Vaughan Bequest, 1900

EXHIBITED: 1891, Royal Academy, London, no. 91.

ENGRAVED: J. Cousen c.1844

LITERATURE: Armstrong 1902, p. 253; Rawlinson 1908, no. 643; Wilton 1979, no. 884.

Cat. no. 2415

About 1825 Turner was commissioned by Charles Heath to supply a series of watercolours to illustrate his publication *Picturesque Views in England and Wales* which appeared in serial issues between 1827-38. The works for this series are among the most elaborate and highly finished designs Turner ever wrought for a series of engravings. Every hour of the day is represented, from sunrise to sunset, by a suffusion of subtly rendered colours and splendid atmospheric effects. Apart from those designs used in the publication, there remain a few highly finished watercolours, which, judging by their style and composition, were originally planned for the series. This view of Folkestone is one such work.

Here Turner presents us with a romantic view of daybreak on Folkestone Beach. The rising sun slowly penetrates through the hazy vaporous atmosphere, suffusing the scene with a bright morning light. Men and women busy themselves with their daily work, preparing the nets for fishing and gathering shell fish thrown up by the morning waves. Folkestone, the nearest point on the southern coast to France, was notorious for smuggling, as is evidenced by the two men burying a keg of whiskey to the right of the picture. In the distance, the outlines of the church are

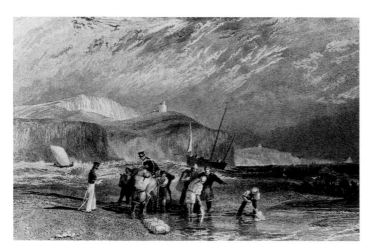

Fig. 28. *Folkestone* (Engraving after Turner, ill. for *Picturesque Views in England and Wales*).

Fig. 29. *Folkestone* (T.B. CCIII-D, Tate Gallery, London). Watercolour.

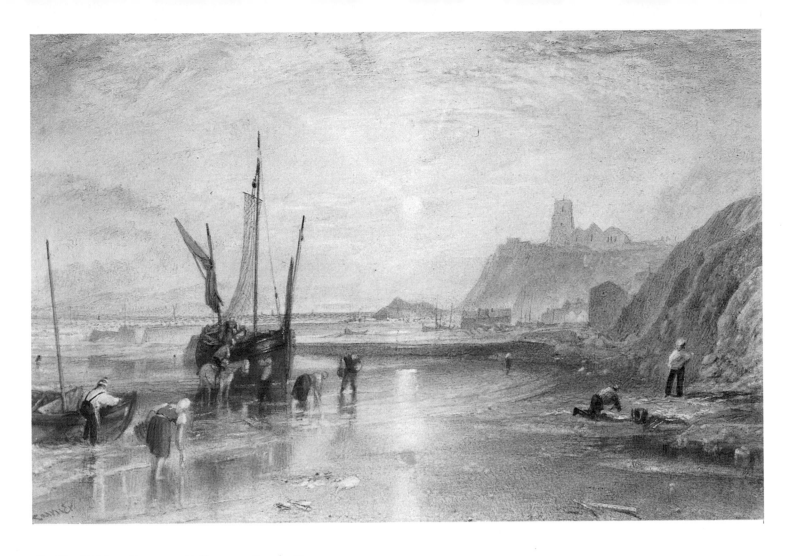

Pl. 17 *Fishing Boats on Folkestone Beach, Kent*

clearly discernible. Known locally as 'Hurricane House' it was so called after the western part of the nave was blown down by a gale in 1805. This watercolour was engraved by J. Cousen for *Dr Broadley's Poems* which were intended to be privately published about 1844. However no evidence of this publication exists. It was printed in 1867 by Virtue & Co. for a volume entitled *Art and Song* edited by Robert Bell, where it illustrated a poem *Down on the Shore* by the Irish poet William Allingham.

Turner was greatly attached to this lovely part of the south coast and made three other watercolours of Folkestone for illustration, one of which appears in the published series of *Picturesque Views in England and Wales* (Fig. 28).

Turner took great care with his designs for publication, working closely with the engraver on the proofs. In a trial proof of this view of Folkestone (British Museum, London) he has written in the margin:

'The Woman's red petticoat lighter. The work of it is rather too ragged - make the whole figure much lighter and then we can make up the best lines. The house is somewhat the same, but do not take away so much. The fishing net is too close in the Mesh which make it look like a sail - what can you do with it?'

A pencil drawing of Folkestone, similar to the Dublin sketch, appears in one of Turner's notebooks (T.B. CCIII-D) (Fig. 29), thus recording a trip to the area about 1824. Written in the margin of this drawing among other notes is *Dover, Folkestone, Lulworth, St. Mawes, Black Gang.* Three of these views, *Dover, Folkestone* and *St. Mawes,* appear in *Picturesque Views in England and Wales,* confirming Turner's interest in the project at that time.

Sunset over Petworth Park, Sussex

c. 1828 (Pl. 18)

Gouache on blue paper, 13.9 × 19.3 cms.

PROVENANCE: Henry Vaughan Bequest, 1900

LITERATURE: Armstrong 1902, p. 271; Wilton 1979, no. 908.

Cat. no. 2430

Lord Egremont, a wealthy landowner in Sussex with an income of over £100,000 a year, was regarded as a princely patron of contemporary English art (Fig. 30). He extended his splendid hospitality to the leading artists of the day. During the 1820s and 30s, Thomas Phillips, Sir William Beechey and the American painter C. R. Leslie among others, stayed with their wives, families and servants for weeks, sometimes months, on end. The house was regarded as a grand hotel and Lord Egremont provided excellent facilities for painting and sculpture, as well as ample opportunity for relaxation (Fig. 31).

Turner first visited Petworth in 1809, and again in 1827, after which time it became his regular retreat outside London. It took the place of Farnley Hall, the home of his old friend and patron Walter Fawkes who had died in 1825. Lord Egremont had been a patron of Turner from the early years - he purchased *Ships bearing up for anchorage,* in 1802 - and Turner was regarded as a privileged guest. He felt at ease in this cultural environment, as his host's motto of 'live and let live' echoed his own sentiments.

Turner's visit to Italy in 1819 and to Venice in particular, had done much to liberate his palette and thus he continued to lighten his colour compositions throughout the 1820s. As the climate of England inclined towards the damp and gloomy, sunsets and sunrises were ideal subject matter for Turner's colour expressions. In this *Sunset over Petworth Park,* the

Fig. 30. *George Wyndham, 3rd Earl of Egremont* by Thomas Phillips (National Portrait Gallery, London, cat. no. 3323).

composition is built up in vivid opaque colours. The sunset is perceived through an atmosphere of light in which the detailed landscape becomes absorbed in the broader colour scheme. Depth and space are created through contrasts of warm and cool colours rather than light and shade. The strong sweeps of blue on the

mountain and lake recede into the background of the picture, while the rich yellow of the sun is projected forward, heralded by the bright rays of light which are emitted at an oblique angle, conveying an expansive area of parkland.

All of Turner's Petworth scenes are on blue paper, a support he began to use for study sketches at East Cowes Castle in 1827. He also favoured these small blue sheets of paper as supports for his designs intended for the *Great Rivers of Europe* series. In all these works the blue paper heightens the intensity of colour applied, thus lending the scene a certain brilliancy.

A similar sunset over Petworth Park, although not quite so vivid in colouring, is in the Turner Bequest (TB. CCXLIV - 18) (Fig. 32).

Fig. 31. *Playing billiards at Petworth* (T.B. CCXLIV-116, Tate Gallery, London). Watercolour.

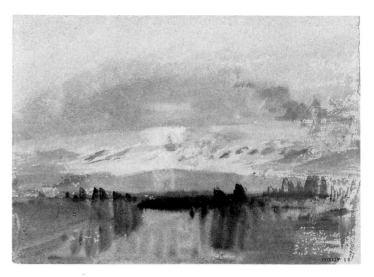

Fig. 32. *Sunset over Petworth Park* (T.B. CCXLIV-18, Tate Gallery, London). Gouache.

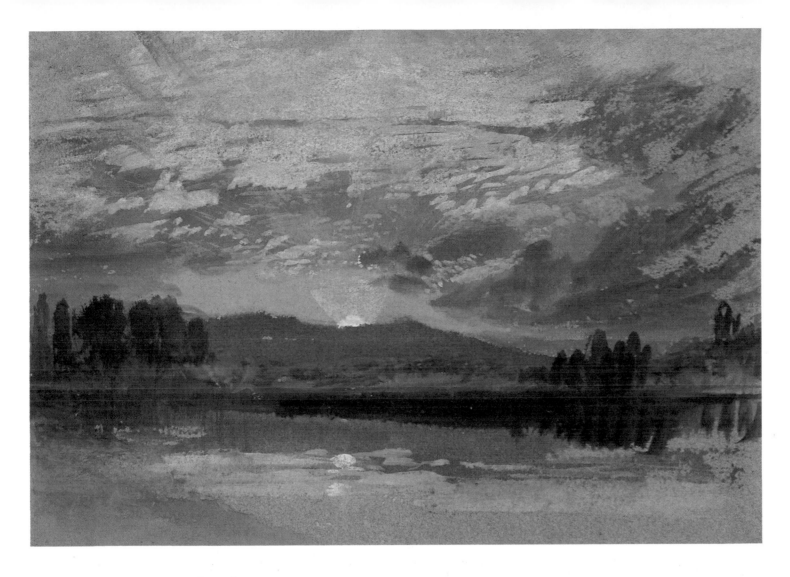

Pl. 18 *Sunset over Petworth Park, Sussex*

Le Pont du Château, Luxembourg

c .1830 (Pl. 19)

Watercolour and bodycolour with some pen on blue paper, 13.9 × 19.1 cms.

PROVENANCE: Henry Vaughan Bequest, 1900

LITERATURE: Armstrong 1902, p. 278; Wilton 1979, no. 1010; Luxembourg 1984, no. 13.

Cat. no. 2429

Between c.1825 and 1835 Turner travelled extensively through northern Europe, gathering material to illustrate the *Great Rivers of Europe* series, which was planned by the publisher Charles Heath. Judging from the tours he made, Turner intended to include views of the Rhine, the Danube, the Meuse and the Moselle and probably the Rhône, the Saône and the Po. However, only the views of the Loire and the Seine were published in 1833. They appeared as two volumes, each containing twenty views.

Nearly all the designs for the *Great Rivers of Europe* series were on blue paper, which Turner had definitely begun to use by 1827. Apart from those finished works used in the published volumes, there remain a number of virtually completed works which are related to the *Great Rivers of Europe* series. Most of these are in the Turner Bequest, but some, like this view of the *Pont du Château, Luxembourg*, were dispersed.

The Pont du Château, a stone bridge built in 1736, links the castle of the Counts of Luxembourg to the higher site of the old city, situated on the Rocher de Bock overlooking the Alcette valley. As in all Turner's drawings on blue paper, the colouring is vivid and strong. The spectacular aquaduct to the left is illuminated by a vortex of light which tumbles through the gateway like a mountain river. To the right is the Porte de Treves and below, the Enceinte de Wenceslas

is clearly outlined. The impregnable rock face of Le Bock is accentuated by Turner's use of fine lines of red ink. He uses this device again, to great effect, in his depiction of *The Grand Canal, Venice*, (Pl. 25).

Turner made his first visit to Luxembourg in 1825. The *Meuse - Moselle* sketchbook (T.B. CCXXI) includes two views of Luxembourg, one of which (P) shows a similar view of the Pont du Luxembourg (Fig. 33). Finberg in his *Inventory of Drawings in the Turner Bequest* dates this sketchbook to 1826. However, it has now been established, based on notes at the back of the *Rivers Meuse and Moselle* sketchbook (T.B. CCXVI), that Turner visited the region a year earlier in 1825. Turner returned to Luxembourg in 1834, where he made further drawings of *Le Pont du Château*, which

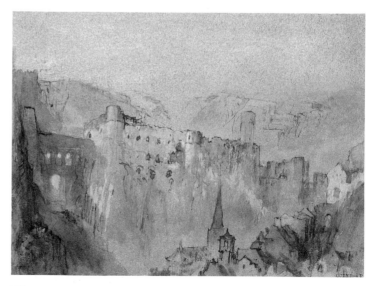

Fig. 33. *Le Pont du Château, Luxembourg* (T.B. CCXXI-P, Tate Gallery, London).

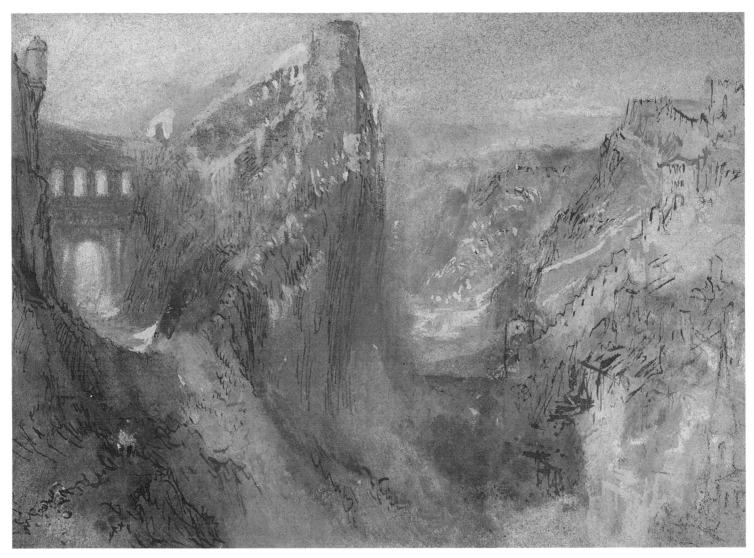

Pl. 19 *Le Pont du Château, Luxembourg*

are included in the *Givet, Mezieres, Verdun, Metz, Luxembourg and Treves* sketchbook (T.B. CCLXXXVIII). Page 62 of that sketchbook shows a similar composition to the Dublin work, with the Pont du Château adjoining the Rocher du Bock to the left of the page. This could suggest the Dublin work was executed after this 1834 visit. However, Turner had begun to use blue sheets of paper about 1827 and while his use of red ink is usually associated with later works, there are examples of its use in watercolours executed in the 1820s, for the *Great Rivers of Europe* series (W. nos. 930-50).

Turner's designs for Finden's Landscape Illustrations of the most Remarkable Places mentioned in the Holy Scriptures.

c. 1832-35 (known as *Finden's Bible*)

In 1832 Turner was offered a commission to supply twenty six drawings for *Finden's Bible*. The work was proposed by the engravers William and Edward Finden who, together with John Murray, were joint publishers. Turner had already collaborated with the publisher Murray on *Picturesque Views of the Southern Coast of England*, and with all three men on a large series of designs for Byron's *Life and Works* (2 vols, pub. 1836). During this period Turner was also supplying watercolours to illustrate the *Poetical Works of Sir Walter Scott* (1832).

Turner was well versed in the scriptures, having throughout his career drawn on Biblical subjects. His first historical landscape, at the Royal Academy in 1800, was the *Fifth Plague of Egypt* which was accompanied by quotations from the book of Exodus. Biblical themes also occur in his *Liber Studiorum* (1808-19)[1], and in later life his expressions of man's relationship with nature have biblical overtones; for example *Shade and Darkness - The evening of the Deluge* (1843) and *The Angel standing in the sun* (1846), which is accompanied by a passage from the Book of Revelation. In 1835 he designed seven vignettes for the publication of John Milton's *Paradise Lost and Paradise Regained*. Five of these have direct connections with the Bible; three from *Paradise Lost* and two from *Paradise Regained*.

The publishers of *Finden's Bible* were quite aware of the neglect of the Holy Land and its antiquities in nineteenth century guidebooks. The eighteenth century, with its urbane classical interests in art and literature, ensured that all literature for the Grand Tour led to Italy and eventually Rome. It was only at the end of the eighteenth century that the Hellenistic traditions of Ancient Greece were rediscovered and the Grand Tour moved eastward. By the nineteenth century the journey included the Holy Land and the Orient, thus increasing the demand for views of the Levant.

Turner had never been to the Holy Land, and so had to base his compositions on other aritsts' drawings of the region. One such artist was the architect Sir Charles Barry (1795-1860), who had travelled to the Middle East between 1817 and 1820. His extensive drawings of the region were among those chosen by the publishers as a basis for *Finden's Bible*. Turner particularly liked Barry's drawings, and fourteen of his watercolours are based on Barry's works, including *Assos*, in the collection of the National Gallery of Ireland.(Pl. 20).

Turner's watercolours of Palestine were described by Ruskin as 'quite unrivalled examples of his richest executing power on a small scale'.[2] They were executed during the period when Ruskin believed Turner produced his most wonderful work (1830-40). For his fellow artists who had been there, it seems unfortunate that Turner never managed to visit the Holy Land. His friend Sir David Wilkie, for example, expressed such an opinion in a letter to Thomas Philips. Writing from Jerusalem in 1841, Wilkie says he thought of 'our highly talented friend Mr. Turner' and he wondered what he would think 'when I tell him I thought of him and wished for him when I passed through the ancient city of Jericho, though then, from the ravages of the retreating army, a smoking ruin. I can fancy what our friend would make of this and the Vale of Jordan, of the Dead Sea, the Wilderness of the Temptation and above all, the Mount of Olives, Mount

of the Ascension with all the mystery associated with it, which (like the top of Fiesole over Florence) overlooks Jerusalem.'[3]

Although he did not have first hand knowledge of the area, Turner produced magnificent scenes of the Levant, imbuing them with a spirit and atmosphere native to that ancient land. Perhaps Ruskin explains it best '....of one thing I am certain, Turner never drew anything that could be seen without having seen it. That is to say though he would draw Jerusalem from someone else's sketch, it would be, nevertheless, entirely from his own experiences of ruined walls'.[4]

The other three artists commissioned on the series were Clarkson Stanfield, James Duffield Harding and Sir Augustus Wall Calcott.

The plates were first issued in parts, then in 1836 the illustrations were published by Murray as a set of two volumes entitled *Biblical Keepsake* or *Landscape Illustrations of the most Remarkable Places mentioned in the Holy Scriptures* with descriptions of the plates by the Rev. Thomas Hartwell Horne B.D..

1. Turner's *Liber Studiorum* included *The Fifth Plague of Egypt, The Tenth Plague of Egypt, Rizpah and the Deluge* and later, *Christ and the woman of Samaria.*
2. Ruskin 1878.
3. Cunningham 1843, p. 205.
4. Ruskin 1903-12, ch. 13, p. 42.

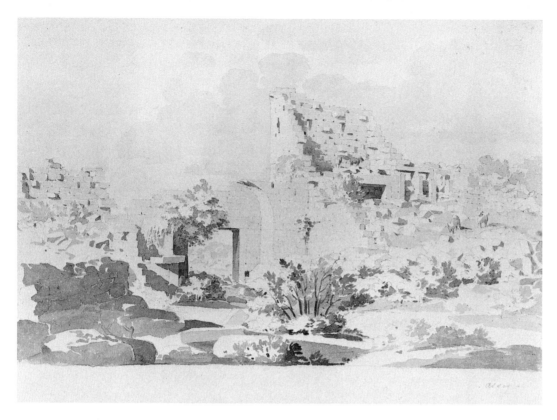

Fig. 34. *Assos* by Sir Charles Barry (British Architectural Library/R.I.B.A.).

Assos, 1832-34

(after a drawing by Sir Charles Barry) (Pl. 20)

Ink and watercolour on paper, 14 × 20.4 cms.

PROVENANCE: Henry Vaughan Bequest, 1900

ENGRAVED: 1834, William Finden for *Finden's Bible.*

LITERATURE: Thornbury 1862, pp. 559, 619; Armstrong 1902, p. 240; Ruskin 1903-12, vol. 3, pp. 340, 423; Rawlinson 1908, no. 594; Jerusalem 1979, no. 1258; Wilton 1979, no. 1258.

Cat. no. 2424

Situated on the Mediterranean, Assos was once the great sea port of Mysia in Asia Minor (now Turkey).

The Acts of the Apostles (ch. 20, vs. 13, 14) recount how St. Paul and his followers were reunited there before going on to Mytilene.

'The rest of us had already embarked and had set sail for Assos, intending there to take up Paul; for this he had directed, intending himself to go by land. So when he met us at Assos, we took him on board and came to Mytilene.'

Assos was one of the views included in William Finden's publication, *Landscape Illustrations of the most*

remarkable places mentioned in the Holy Scriptures. Turner was commissioned to execute twenty four designs for this publication. As he himself had never been to the Middle East, he had to base his works on other artists' drawings of the region. Turner particularly liked the drawings of the Levant by Sir Charles Barry (1795-1860), who, with David Baillie, had toured the region between 1817 and 1820. This view of Assos is based on Sir Charles' work (Fig. 34). Turner has emphasised the ruined battlements and classical lintels,the few remaining testimonies to a once noble Greek city. An air of desolation prevails, heightened by the presence of a few European tourists who, with their guides, clamber over the ancient ruins. Above, the angry clouds gathering over the site herald the arrival of a thunderstorm. *Babylon*, another of Turner's biblical illustrations for Finden's publication, was also in Vaughan's collection. Based on a drawing by Sir Robert Kee Porter, it is now in the Victoria and Albert Museum Collection (Fig. 35).

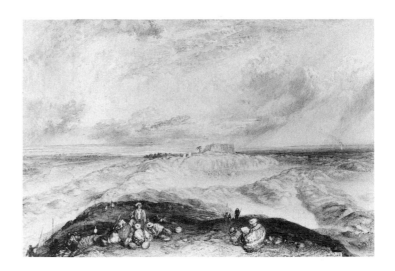

Fig. 35. *Babylon* (Trustees Victoria and Albert Museum, London, cat. no. 982-1900). Watercolour.

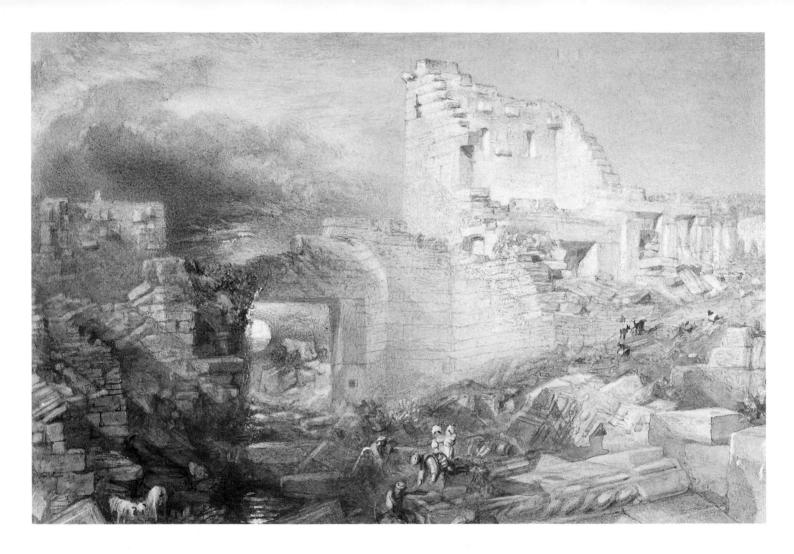

Pl. 20 *Assos*

Turner's journey to the continent in 1836

In 1836 Turner set out on a tour of the continent, visiting France, Switzerland and the Val d'Aosta. It was thirty four years since he had visited Switzerland; his interpretation of the scenery was now more prosaic than sublime. He invited his friend and patron, H. A. J. Munro of Novar, to accompany him. Munro was a wealthy landowner with large estates in Scotland. A keen amateur painter himself, he was an enthusiastic collector of Turner's works.[1] Due to his wealth and standing in Scotland, his neighbours there were exhorting him to go into politics, a career entirely unsuited to him on account of his shy and retiring disposition. Perceiving his predicament, Turner proposed that he join him on a sketching tour of the continent. Munro gladly accepted and they set off in the late summer of 1836.

Crossing from Dover to Calais, Munro noted that Turner wished to take a route he had not previously travelled. So they travelled through Arras, Rheims and Chaumont to Dijon where they crossed over to Geneva and then down to Val d'Aosta and Turin. There Turner left Munro and travelled back to England. *The Fort Bard* (T.B. CCXCIV) and the *Val d'Aosta* (T.B. CCXCIII) sketchbooks contain pencil sketches of this tour. However, we have reliable information from Munro that Turner also carried out, on the spot, colour sketches which are now dispersed. About the time of the Swiss tour, Turner began to replace his hard backed notebooks with paperbacked or roll sketchbooks which he could easily stuff into his pockets. Many pages of the roll sketchbooks on this trip were filled with colour studies. Later they must have been dismantled and the colour studies dispersed. Two of these colour sketches, *Tête Noire* (Pl. 21) and *An Alpine Pass in the Val d'Aosta* (Pl. 22) are now in the National Gallery of Ireland's collection. Munro also tells us that he offered to buy all Turner's coloured drawings at the end of the journey and was rather hurt because Turner would not let him have them.

After his previous visit to Switzerland in 1802, Turner made a series of watercolours based on his sketches. This time he did not produce any finished watercolours of Switzerland.[2] He did produce one oil painting *Snow-Storm, Avalanche and Inundation* - a scene in the upper part of Val d'Aosta, Piedmont, which was exhibited at the Royal Academy in 1837 (Art Institute of Chicago) (B/J 371).

1. At the Royal Academy in 1836, Munro bought two of the three oil paintings by Turner. He would have liked to take the third, but he 'was ashamed of taking so large a haul' (Finberg 1939, p.359). He also owned about 130 watercolours by Turner, making him one of his most important later patrons.

2. Finberg believes there was one of Geneva. See A. J. Finberg, 'With Turner in Geneva', *Apollo* (January 1925).

Tête Noire Mountain, near Villar D'Arene, France (1836) (Pl. 21)

Watercolour on paper, 25.5 × 28.2 cms.

WATERMARK: (?) *1827 B.E. & S*

PROVENANCE: Henry Vaughan Bequest, 1900

LITERATURE: Armstrong 1902, p. 280; Wilton 1979, no. 1441; Paris 1981-82, no. 155.

Cat. no. 2421

This view of Tête Noire is one of the colour studies Turner made on his tour of Switzerland in 1836. Now over sixty years old, Turner's response to the Alpine scenery had somewhat changed. On his earlier visit in 1802, he had concentrated on the sublimity of the landscape, conveying the awesome majesty of the Alps. By contrast, these later sketches capture the lively changing moods of the mountains. *Tête Noire* conveys a fleeting vivid impression of mountain peaks bathed in sunlight. Turner's loose fluid brushwork builds up the composition in strong contrasting colours. Against the bright sunlit background, the severity of Tête Noire is emphasised. Despite the brilliant sunshine, its sheer face retains a blackish hue which, no doubt, gave rise to its name.

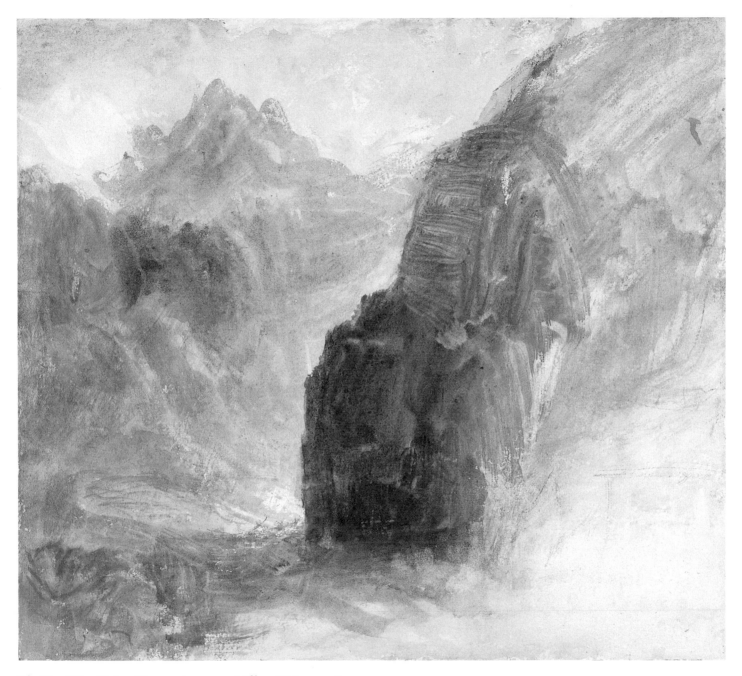

Pl. 21 *Tête Noire Mountain, near Villar D'Arene, France*

An Alpine Pass in the Val d'Aosta,

c.1836 (Pl. 22)

Pencil and watercolour on paper, 24.2 × 30.6 cms.

PROVENANCE: Henry Vaughan Bequest, 1900

LITERATURE: Wilton 1979, no. 1442.

Cat. no. 2419

Many of Turner's sketches made on this second trip to Switzerland were executed from viewpoints accessible only on foot. Here Turner conveys the great vastness of the Val d'Aosta. Seen from a dizzying height, the mountain peaks melt into the evanescent light. Floating clouds increase the fleeting effect, and one can barely discern the outlines of the figures to the left looking down on the fortress below.

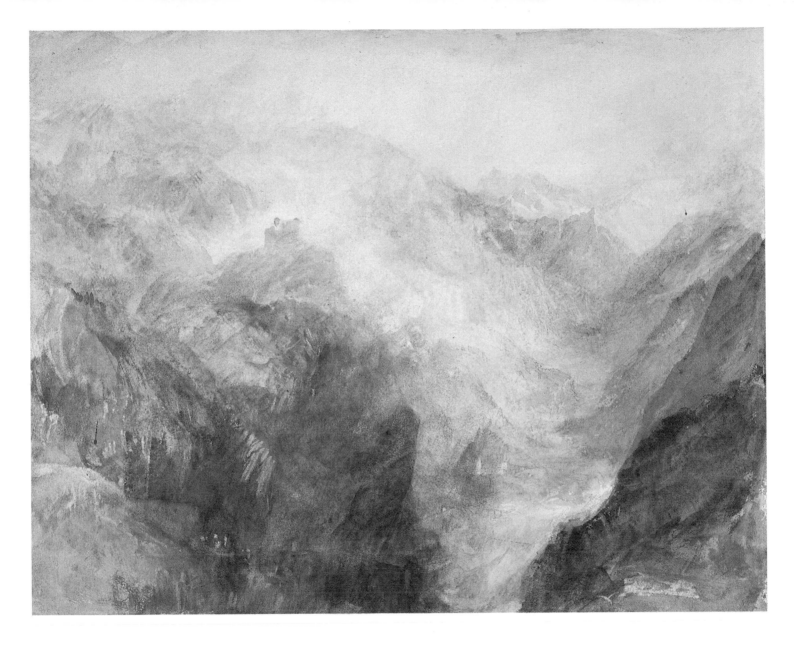

Pl. 22 *An Alpine Pass in the Val d'Aosta*

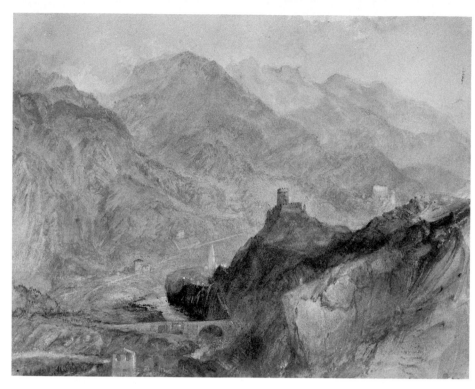

Fig. 36. *Châtel Argent in the Val d'Aosta* (National Galleries of Scotland, cat. no. D (N.G.) 870). Watercolour.

Châtel Argent, near Villeneuve, Switzerland c.1836 (Pl. 23)

Pencil and watercolour on paper, 24.1 × 29.8 cms.

PROVENANCE: Henry Vaughan Bequest, 1900

LITERATURE: Armstrong 1902, p. 259; Wilton 1979, no. 1442; Edinburgh 1980, p. 30.

Cat. no. 2416

Judging from its style and technique, this watercolour dates from Turner's 1836 tour of Switzerland. Compared to the two other sketches in the National Gallery of Ireland's collection, it is, however, a more finished work. Another version of this subject, seen from a different perspective, is found in the Vaughan Bequest at the National Gallery of Scotland (Fig. 36). Like *Pont du Château, Luxembourg* (Pl. 19), this view may have been intended for Charles Heath's publication *Great Rivers of Europe*. This project was eventually abandoned and some of the colour studies such as this work were dispersed. The *Fort Bard* sketchbook (T.B. CCXCIV) contains some pencil sketches of the vicinity of Châtel Argent, confirming, Turner's visit there in 1836.

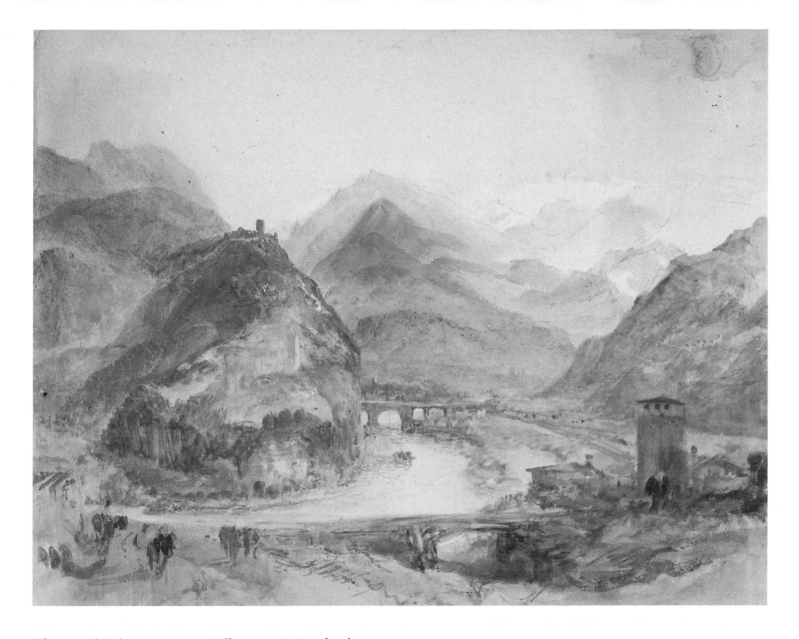

Pl. 23 *Châtel Argent, near Villeneuve, Switzerland*

Turner's Venice 1819, 1833 and 1840

In 1819, Turner made his first visit to Italy, which was still considered the cultural mecca of the Western world. In the eighteenth century, people experienced a renewed interest in the Hellenistic art of ancient Rome. This was further fuelled by archaeological discoveries at the buried cities of Pompeii and Paestum. Coupled with this interest in ancient culture was a reassessment of Renaissance art. Both artists and connoisseurs flocked to Italian shores and Rome became the ultimate destination on the Grand Tour itinerary.

As a landscape painter, Turner was inevitably influenced by paintings of the Italian campagna. He especially admired the work of Claude Lorraine, the great seventeenth century landscape artist,who spent most of his working life in Rome. His work was well represented in private English collections and Turner constantly sought to emulate and surpass his genius. Two English artists, John Robert Cozens (1752-99) and Richard Wilson (1714-82), also found their greatest source of inspiration in the Italian countryside. Their work, which heralds the romantic tradition of landscape in England, was much admired by Turner and no doubt provided him with a further incentive to visit Italy.

So, at the beginning of August 1819, Turner at the age of forty four set out for Italy. He travelled down through France and crossed over the Mont Cenis Pass into Italy. He spent some time around Lake Como and Turin before moving on to Milan. From Milan he travelled further east, via Verona, to Venice.

Despite its obvious charms, eighteenth and early nineteenth century British painters rarely bothered to visit Venice, preferring to head directly south to Rome.

Wilson and Cozens were among the few who did; Wilson went there in 1752, while Cozens accompanied his patron William Beckford there in 1782, but it appeared English travellers preferred the panoramic *vedute* painted by the Italian artist Canaletto to any works by their native artists. Canaletto's dramatic, picturesque views had virtually cornered the Venetian market in England and such was his appeal that mediocre works after his style continued to appear on the market well into the nineteenth century. Venice was brought to Turner's attention when, in 1818, the year before he set out for Italy, he had provided illustrations for his friend James Hakewill's publication *Picturesque Tour in Italy*. As Turner had no direct impressions on which to base his work, he relied on Hakewill's pencil drawings which the architect himself had made, with the aid of a *camera obscura*. Included in this *Picturesque Tour* were two Venetian scenes. Hakewill most probably encouraged Turner to make a detour across Northern Italy over to the Adriatic. He had kindly written out a manuscript guide for the artist, which Turner labelled *Route to Rome*. This included tips on good hostelries to frequent, worthwhile views to observe and preferable modes of transport. Here is a sample of Hakewill's advice (as quoted in Wilton 1982, p. 17) 'At Milan - Go to the Albergo Reale in the Street tre Re (sounded tra ra). The Inn kept by Baccala - A few doors higher up lives a printseller who talks English well, and will be civil, buying of him the Maps &c. which you may want - perhaps he will remember my name On no account trust yourself in a felucca - But hire horses & guides to Spezia.........The Dongella, dear but good........'

Travelling in Italy was both expensive and hazardous. Tourists were considered worthy prey for inn keepers and guides. Thus Hakewill's guidance was invaluable to a first time visitor.

Venice also came to Turner's attention in 1818 with the publication of Lord Byron's fourth canto in his epic poem *Childe Harold's Pilgrimage*. This canto finds Harold exploring the delights of Venice. Byron's work was familar to Turner and he identified with the Romantic ideals expressed in Byron's poetry. Earlier that year, he included a quotation from the third canto as an accompaniment to his *Field of Waterloo* (B/J 138) which was exhibited at the Royal Academy.

Byron's introductory stanzas in the fourth canto sum up the romantic imagery of Venice:

'She looks a sea Cybele, fresh from ocean,
Rising with her tiara of proud towers
At airy distance, with majestic motion,
A ruler of the waters and their powers:
And such she was; her daughters had their dowers
From spoils of nations, and the exhaustless East
Pour'd in her lap all gems in sparkling showers.
In purple was she robed, and of her feast
Monarchs partook, and deem'd their dignity
 increas'd.'

(Stanza II)

Despite its obvious beauties, Venice proved a disappointment to many of her visitors. Thomas Moore wrote of the 'disenchantment one meets with at Venice - the Rialto so mean - the canals so stinking and the most barbaric appearance of the Piazzetta of St. Mark with its extraordinary Ducal Palace, and fantastical Church, and gaudy clock opposite'.[1]

However Turner's enchantment with Venice is obvious in his work and he made three visits there altogether. On his first visit in 1819 the *Gazetta Privilegiata di Venezia* records him as having arrived on the September 8 or 9 - 'Turner William, gent inglese' - from Milan.[2] He produced just four watercolours on this trip. (T.B. CLXXI 4-7). For the rest of the time he was busily recording scenes in pencil which fill parts of two sketchbooks, *Milan to Venice* (T.B. CCXXV) and *Venice to Ancona* (T.B. CCXXVI). Upon his return to London, and for the next decade or so, he produced many oil paintings of Venice.

Turner waited fourteen years before returning to Venice in 1833[3] and he made his final visit there in 1840. In total he produced about 170 watercolours of the city, twenty six of which are outside the Turner Bequest. The Henry Vaughan Bequest includes nine Venetian watercolours which form a significant part of those outside the Turner Bequest. Six of these are in the National Gallery of Scotland. The remaining three are in the National Gallery of Ireland.

1. Moore 1853-60, p. 598.
2. George 1971, vol. 53, p. 71.
3. Finberg dates the second visit to 1835. See Finberg 1930.. However it is now generally accepted that it was 1833. See George 1971, *ibid*.

Turner may have spent some time in Venice on other occasions in the 1830s, as he disappeared on sketching holidays abroad, not recording where he visited.

The Grand Canal from below the Rialto Bridge, Venice

c. 1820 (unfinished) (Pl. 24)

Pencil and watercolour on paper, 28.3 × 40.7 cms.

WATERMARK: *J. Whatman 1818 Turkey Mill*

PROVENANCE: Robert Dunthorne Bryce, by whom presented to the nation, 1972.

EXHIBITED: 1983, *Master European Drawings from the National Gallery of Ireland*, Smithsonian Institute, Washington.

LITERATURE: Wilton 1979, no. 725; Smithsonian Institution 1983, p. 148; Stainton 1986, p. 17.

Cat. no. 7512

In Venice, taking Hakewill's advice, Turner most probably stayed at the Leone Blanco Hotel on the Grand Canal, the San Marco side of the Rialto Bridge. Turner had, before journeying to Italy produced a watercolour of this famous bridge for Hakewill's

Fig. 37. *The Rialto Bridge, Venice 1818* (engraving after Turner, ill. for Hakewill's *Picturesque Tour in Italy* — British Museum, cat. no. 192584).

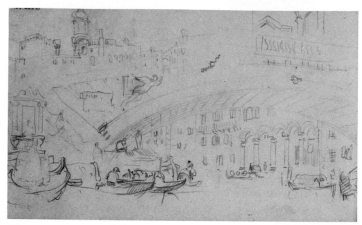

Fig. 38. *View of the Rialto Bridge with Fondaco de' Tedeschi and other buildings seen through its arch* (T.B. CLXXV-79, Tate Gallery, London). Pencil.

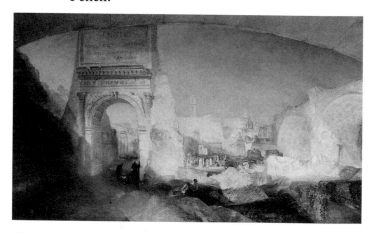

Fig. 39. *Forum Romanum* (Tate Gallery, London, cat. no. 9744). Oil.

Picturesque Tour in Italy, (Fig. 37) based on the architect's own sketches.

Now, seeing the bridge for the first time, he filled many pages of his *Milan to Venice* sketchbook (T.B. CLXXV) with drawings, showing the bridge from a variety of viewpoints. On his return to London in

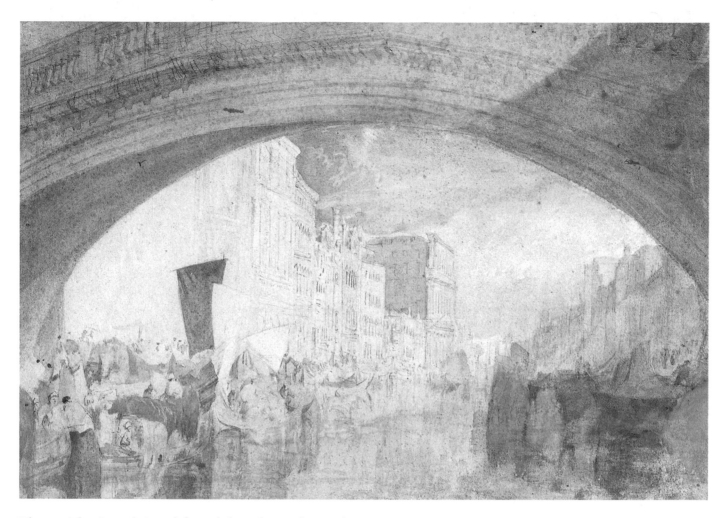

Pl. 24 *The Grand Canal from below the Rialto Bridge, Venice*

1820, he produced a series of of Italian scenes for his old patron Walter Fawkes. The unfinished Dublin watercolour may have been intended for that series. Based on his drawing in the *Milan to Venice* sketchbook (T.B. CLXXV) (Fig. 38), the viewpoint is unusual as it looks underneath the bridge towards San Marco. It is a lively scene which, despite its unfinished state, conveys the hustle and bustle of that area.

Turner attempted an oil painting of the Rialto Bridge, based on the same perspective as the Dublin watercolour (Tate Gallery, London) (B/J 245) but this he also abandoned.

A view of the *Forum Romanum* (Tate Gallery, London) (B/J 233) as seen through the Arch of Titus, executed for the Soane Museum in 1826, employs successfully the same compositional structure (Fig. 39).

105

The Grand Canal, Venice

c. 1840 (Pl. 25)

Watercolour on paper, 21.8 × 31.8 cms.

PROVENANCE: Henry Vaughan Bequest, 1900

EXHIBITED: 1892, *Winter Exhibition*, Royal Academy, London, no. 66.

LITERATURE: Armstrong 1902, p. 282; Finberg 1930, p. 160; Sutton 1971, pp. 168-75; Wilton 1979, no. 1358; Stainton 1986, no. 80.

Cat. no. 2426

This view shows the approach to the Grand Canal from the Molo. In the distance to the right is San Giorgio Maggiore. The topographical features are slight and the sides of the buildings only are delineated by fine vertical strokes of red ink. Here the sky and the sea are the dominant features, being stronger in colour than the surrounding architecture. A storm threatens, with dark rain clouds ominously gathering overhead. The spectacular Venetian storms were by the mid nineteenth century included in Romantic travel literature on the area. It is interesting to note that the four storm scenes Turner produced among his last group of Venetian watercolours were all acquired by patrons, perhaps being more comprehensible than his highly personal, brilliantly coloured views of the city in calm weather.

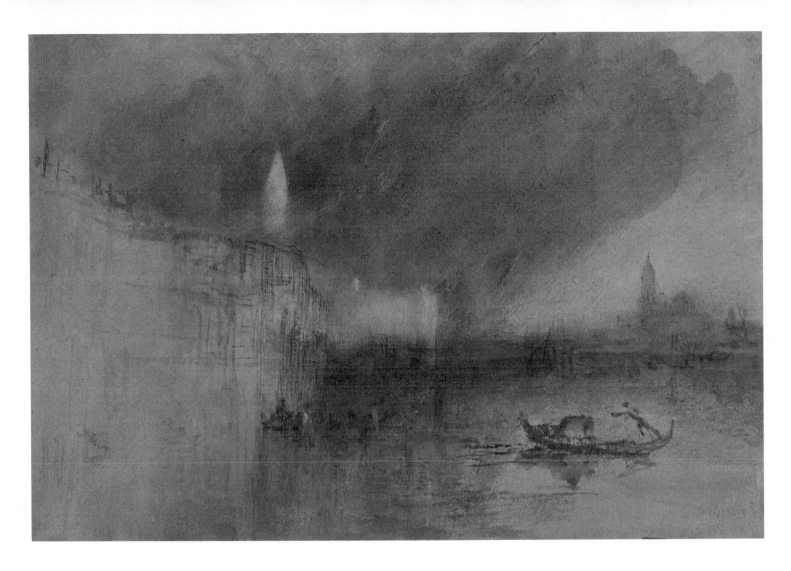

Pl. 25 *The Grand Canal, Venice*

The Doge's Palace and Piazzetta, Venice c.1840 (Pl. 26)

Watercolour on paper, 24 × 30.1 cms.

WATERMARK: *C. Ansell 1828*

PROVENANCE: Henry Vaughan Bequest, 1900

LITERATURE: Armstrong 1902, p. 139, 282, p. 123 (illus.); Finberg 1930, p. 161; Wilton 1979, no. 1356; Stainton 1986, no. 90; Finberg 1930, p. 161.

Cat. no. 2423

This watercolour belongs to the more highly finished works Turner produced after 1840. The view of the Piazzetta di San Marco and the Doge's Palace, seen from the open waters of the Bacino was one of Turner's favourite viewpoints in Venice. Built up in broad washes of colours, the buildings, although easily discernible, lose their weightiness and appear to merge into the hazy atmosphere. Touches of body colour heighten the effect, with Turner using red ink to delineate some outlines more sharply. The wonderful contrasting colours are each possessed of an individual luminosity. The rosy red Doge's Palace stands alongside the pale violet Zecca. Above, the brilliant yellow sky dominates, while the sea green water throws up shadows of the black gondolas. Turner skilfully weaves all these brilliant colours into a harmonious patchwork which shimmers in the morning light.

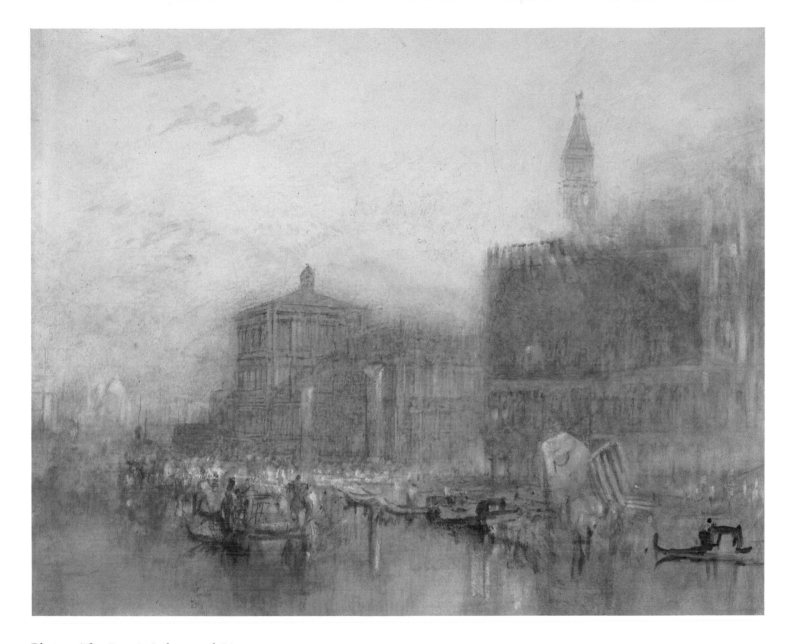

Pl. 26 *The Doge's Palace and Piazzetta*

(?) *San Giorgio Maggiore, Venice*

c. 1840 (Pl. 27)

Pencil and watercolour on paper, 22.4 × 29 cms.

PROVENANCE: Henry Vaughan Bequest, 1900

LITERATURE: Armstrong 1902, p. 282; Finberg 1930, p. 161; Wilton 1979, no. 1357; Stainton 1984, no. 76.

Cat. no. 2417

In his autobiography, William Callow recounts how he met Turner in Venice one evening when he was relaxing in a gondola. He saw Turner sitting in another, sketching San Giorgio, brilliantly lit up by the setting sun. 'I felt quite ashamed of myself idling away my time while he was hard at work'.

This watercolour has a dreamlike quality about it. Seen as a mass of delicate colour, the solidity of form dissolves into the brilliantly lit atmosphere and reappears in the evanescent reflections below. Turner's wide expanse of water allows the churches' reflections to float above the water rather than plunge right into it. Ruskin, in his introduction to *Harbours of England*, points out that 'it is the easiest thing in the world to give a certain degree of depth and transparency to water; but it is next to impossible to give a full impression of surface.'

The washes of pure, lightly applied colour skilfully allow the off white paper to show through. Here and there, by overlapping fine brushstrokes of yellow, Turner increases the brilliance, but not the density, of colour.

Extremely fond of yellow, much to some critics' dislike, he jokingly refers to this in a letter to Holsworthy (May 6, 1826) '..... but I must not say yellow, for I have taken it all to my keeping this year so they say. And so I meant it to be - but come and see for yourself'.[1]

It must, however, be pointed out that it is doubtful whether this view is actually of San Giorgio Maggiore. Lindsay Stainton[2] argues that, due to the relationship of the campanile to the church, and other architectural discrepancies, it may be a church on another island. But, on consideration, it might be more accurate to refer to this view as a *capriccio*.

1. Gage 1980, no. 116.
2. Stainton 1985, p. 62.

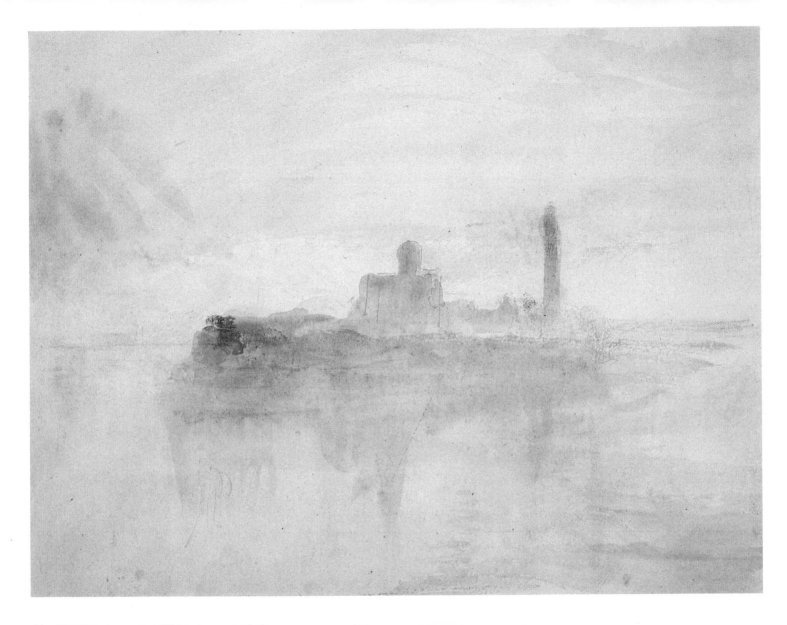

Pl. 27 *San Giorgio Maggiore, Venice*

Great Yarmouth Harbour, Norfolk

c. 1840 (Pl. 28)

Ink and watercolour on paper, 24.5 × 36 cms.

PROVENANCE: Henry Vaughan Bequest, 1900

LITERATURE: Armstrong 1902, p. 286; Wilton 1979, no. 1408.

Cat. no. 2425

Turner paid a visit to Yarmouth on his tour of the east coast in 1824. It is not certain, however, whether or not he ever returned there. Consequently this drawing, executed c. 1840, may be the result of an image conjured up from memory. It is a contemplative scene with a solitary figure observing the fiery sunset.

The architectural features are scarcely discernible, except for the lighthouse and the windmill which, together with the walled structure below, are clearly defined by fine pen strokes - a device Turner favoured in many of his later works. In both style and temperament, this drawing is similar to the Venetian studies of 1840, hence the dating, and, like *San Giorgio Maggiore* (Pl. 27), is pervaded by a certain dreamlike quality.

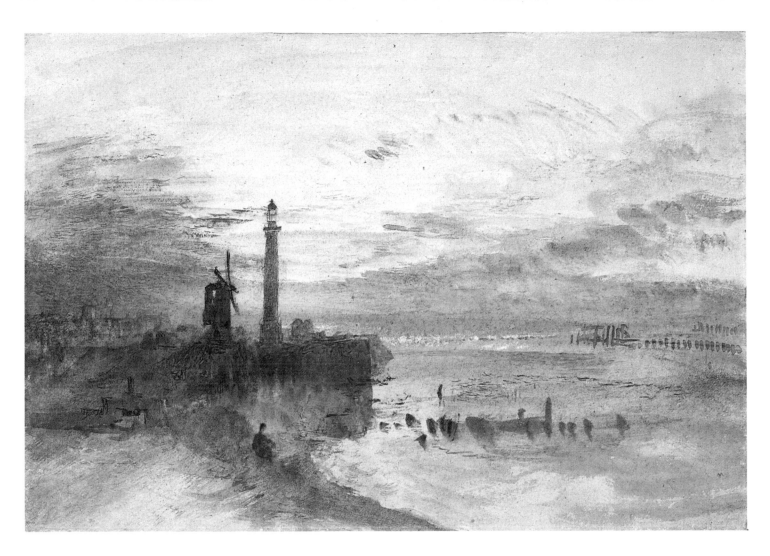

Pl. 28 *Great Yarmouth Harbour, Norfolk*

Bregenz, Lake Constance, Austria,
c.1840 (Pl. 29)

Black chalk, gouache and pencil on blue paper, 19 × 28 cms.
PROVENANCE: H. W. Pewening; Robert Dunthorne Bryce, by whom presented to the nation, 1972.
LITERATURE: Wilton 1979, no. 1351.
Cat. no. 7511

On his way to Venice in 1840, Turner passed through Bregenz, situated on the Swiss Austrian border. A fellow traveller, who signed himself E.H. (possibly the son of James Hakewill) and his wife accompanied Turner along the Rhine and on to Bregenz, where they parted company. E.H. wrote to Turner in Venice, describing the remainder of their journey to Rome. Dated August 24, this letter confines Turner's visit to Bregenz to around August 10 or 11:

'We both hope this letter will find you well at Venice, after we left you at Bregenz we soon found ourselves among the mountains and from the fineness of the sky anticipated, a clear day for the Splugen....'[1]

Viewed to the left of Lake Constance, the town is cast into shade by the evening sun's fiery glow which is reflected across the smooth surface of the water. Above the town's buildings looms the Martinstrum (1599-1602). Its onion shaped dome, clearly defined in the fading light, dominates the view. The subdued opaque colouring, signalling the end of day, evokes a restful atmosphere. Sketches on pages 3a and 4a of the *Rotterdam to Venice* sketchbook (T.B. CCCXX) are similar, topographically, to the Dublin watercolour and appear to be the basis for this work. Executed on blue paper, which was rather unusual for Turner at this late stage, this work may have been originally planned as part of a series of views. There are two other drawings which correspond closely with it in style, technique and size, and all three views were possibly intended to form part of the same series. The other two drawings are tentatively identified as *Heidelberg* (private collection, W. 1349) and *Locarno* (Courtauld Institute of Art, London [72] W.1350). However, of the three, only the Dublin work is on a blue paper support. This may suggest that it was intended for a separate series, or else that the support of the other two drawings has somewhat faded.

1. Gage 1980, no. 236.

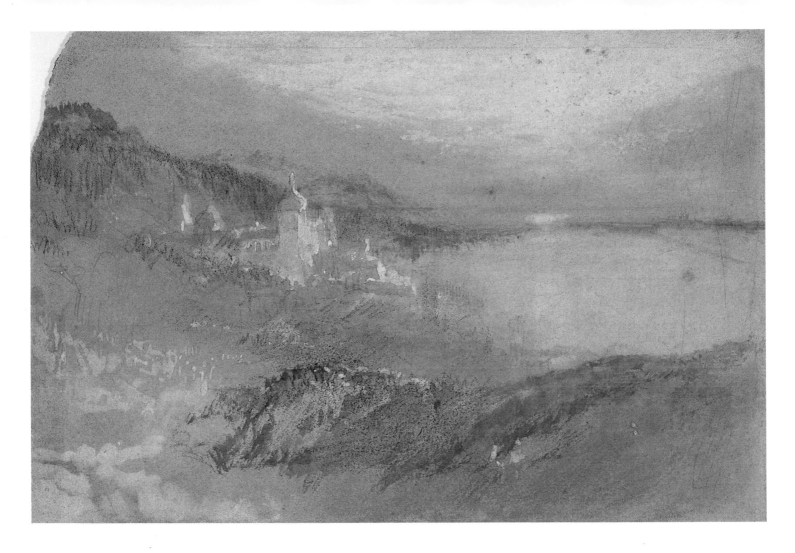

Pl. 29 *Bregenz, Lake Constance, Austria*

Passau, Germany, at the confluence of the Rivers Inn and Danube,

1840 (Pl. 30)

Ink, pencil and watercolour on paper, 24.1 × 30.4 cms.
PROVENANCE: Henry Vaughan Bequest, 1900
LITERATURE: Armstrong 1902, p. 270; Wilton 1979, no. 1317.
Cat. no. 2418.

When Turner left Venice in August 1840, he travelled northwards through Innsbruck to Passau which is charmingly situated on the conflux of the Inn and the Danube. In this watercolour, Turner gives us an aerial view of the town. The panorama is seen through a hazy blue atmosphere, enhanced by the steam emitted from the ferries which ran between Passau and Kinz. The pale diffused lighting creates a dreamlike transient landscape into which the background features dissolve. Towards the foreground, the minutely applied brushstrokes break up the light and allow the architectural outlines to emerge. In the centre is the lofty dome of St. Stephen's Cathedral, while to the right, above the steeple of Salvator Kirche, the Oberhaus commands a dominant view of the Danube.

Fig. 40. *Passau, Germany* (T.B. CCCXL-3, Tate Gallery, London). Watercolour.

This dramatic view of Passau is an example of the energy and passion with which Turner responded to nature in his later years. He suffuses the scene with minutely rendered detail which merges into a harmonious unity through the interaction of colour.

The *Grenoble* sketchbook, (T.B. CCCXL), contains on page 3 a view of Passau seen from a different perspective (Fig. 40).

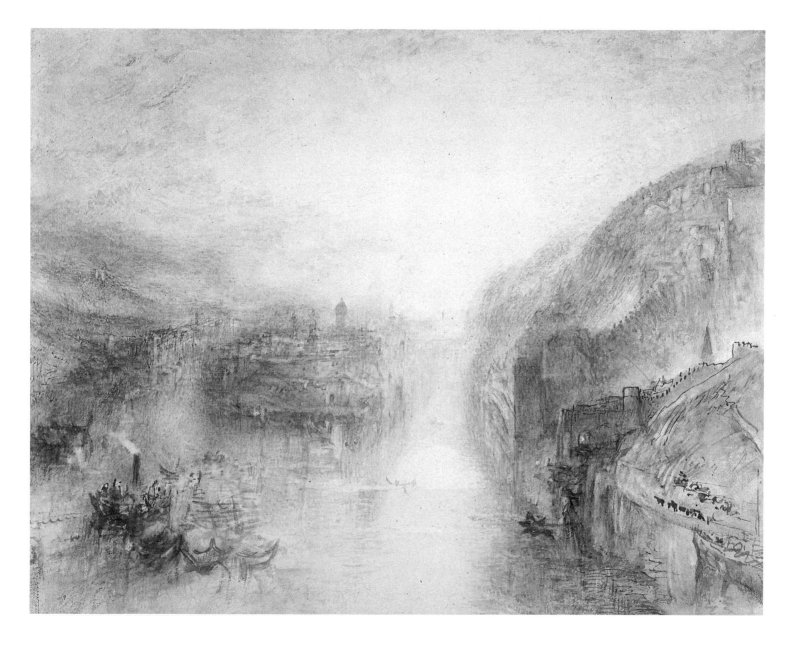

Pl. 30 *Passau, Germany at the confluence of the Rivers Inn and Danube*

The Fortresses of Uri, Schwyz and Unterwalden: Bellinzona, Switzerland 1842/43 (Pl. 31)

Pencil and watercolour on paper, 22.7 × 28.6 cms.

WATERMARK: *J. Whatman*

PROVENANCE: Henry Vaughan Bequest, 1900

LITERATURE: Armstrong 1902, p. 242; Wilton 1979, no. 1491.

Cat. no. 2420

Turner visited Bellinzona in 1842 and in 1843 when he produced a number of beautiful drawings of the area. These include views of the three castellated fortresses Uri, Schwyz and Unterwalden, named after the three cantons, which in 1307, according to legend, formed a league against their neighbouring oppressors.

In this watercolour the Castello Grande (Uri) dominates. Down to the right, the campanile of the Chiesa Collegiata dei Ss. Pietro e Stefano is barely discernible. Behind is the fortress of Schwyz, while that of Unterwalden is loftily perched on a distant hill.

Composed in pencil and watercolour, the architectural features are clearly defined while the treatment of the foreground is looser in detail. The fortresses are bathed in a soft mauve evening light, with the end of the day announced by the rising moon to the left.

Another study of Bellinzona appears in the *Berne, Heidelberg and Rhine* sketchbook (T.B. CCCXXXVI-15) (Fig. 41). The Dublin drawing most probably belongs to the same sketchbook as the architectural delineations and overall viewpoints are similar. A drawing in the City of Manchester Art Gallery also belongs to this group. Its foreground figures, however, are more clearly defined than those in the Dublin work (Fig. 42).

Fig. 41. *Bellinzona from the south* (T.B. CCCXXXVI-15, Tate Gallery, London). Watercolour.

Fig. 42. *Bellinzona, Switzerland* (City of Manchester Art Gallery, cat. no. 1917.100). Watercolour.

118

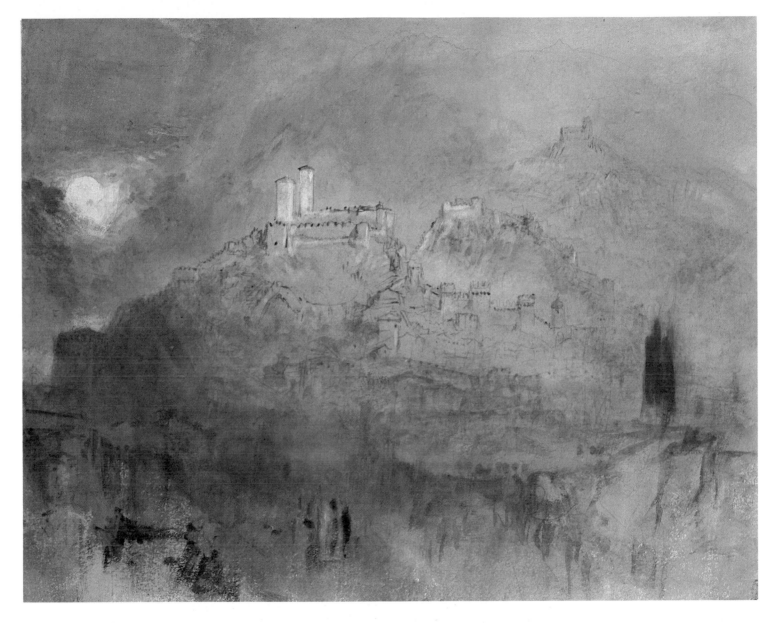

Pl. 31 *The Fortresses of Uri, Schwyz and Unterwalden: Bellinzona, Switzerland*

Thurnberg Fortress and Wellmich, on the River Rhine, Germany c.1844 (Pl. 32)

Watercolour on paper, 18.3 × 24.2 cms.

PROVENANCE: Miss A. Callwell Bequest, 1904

LITERATURE: Wilton 1979, no. 1343; Smithsonian Institution 1983, p. 146.

Cat. no. 3776

When Turner left Switzerland in 1844, he returned home via Germany. This route took him up along the banks of the Rhine to Heidelberg. *The Rhine and Rhine Castles* sketchbook (T.B. CCCLI) is filled with drawings of ruined castles perched atop mountainous terrain overlooking the river. Bearing the watermark *J. Whatman 1844,* the sketchbook confirms Turner's visit to the region that year.

This watercolour conveys a spectacular view of Wellmich village (now St. Goarshausen) commanded by the ruined fortress of Thurnberg, which is referred to locally as Burg Maus (Mouse Castle). Begun in the 1350s by Archbishop Bormund of Trier, the construction was completed in 1362 by Archbishop Kuno von Falkenstein. Built in the Gothic style, the castle is flanked by small cover towers which were typical in Rhineland castles of the fourteenth century. Turner pays far more attention to detail in the castle's outline than to the imposing Gothic church and bell tower in the centre of the town. A dispersed page from a small notebook, smaller than those generally used by Turner on his late continental tours, this drawing does not bear a watermark. However, the blunt pencil outlines which emerge through broad washes of pale, almost translucent colour suggest a date of 1844.

Pl. 32 *Thurnberg Fortress and Wellmich, on the River Rhine, Germany*

A View of Bacharach, Germany

c. 1844 (Pl. 33)

Pencil on paper, 18.3 × 24.2 cms.

Cat. no. 3776 (*verso* of Pl. 32).

Bacharach, situated further down the Rhine from Wellmich, at the entrance to the Steeger Thal, was noted for its picturesque medieval appearance before a disastrous fire in 1872 destroyed most of its timber edifices. The town is enclosed by castellated walls which descend from the ruined fortress of Stahleck which was built by the Counts Palatine in the twelfth century. To the right of the drawing, the campanile of the Church of St. Peter or Templars' Church is clearly discernible as is the fine early Gothic porch beside it.

Built up in quick assured pencil outlines, this sketch is similar to many pencil drawings of Rhine subjects in the Turner Bequest.

Pl. 33 *A View of Bacharach, Germany*

Turner's last visits to Switzerland

Turner returned to Switzerland every summer between 1841 and 1844. Ever since his first visit there in 1802, the Swiss landscape held for him a tremendous fascination. He revisited, over these four years, some of his old haunts, Lake Lucerne, the Rigi mountain and the Splugen Pass to name a few. They once again served as a powerful stimulus to his imaginative and creative powers and the Swiss scenery evoked in him a new intensity of expression. The twenty six finished watercolours completed as a result are among his greatest expressions of communication with nature.

In the 1840s Turner no longer produced series of watercolours on commission but it appears he still liked to work on a thematic structure. Ruskin tells us that in the winter of 1841, after his return from Switzerland, Turner placed fifteen sketches with his agent Mr. Griffith from which he proposed to make ten drawings. Four of these sketches were finished drawings, samples of what he intended to do to manifest what their quality would be and honestly show his hand at his sixty-five years of age - whether it shook or not, or had otherwise lost its cunning.[1] These four were *The Pass of Splugen, Mont Rigi Morning* (or *The Blue Rigi*), *Mont Rigi* (or *The Red Rigi*), *Lake Lucerne: The Bay of Uri from above Brunnen*. Griffith could only manage to sell nine finished works but agreed to take the tenth as his commission. Turner sold them for eighty guineas each, although Ruskin believed he wanted a hundred guineas. This method of placing sketches with his agent was a new departure for Turner. It was an unusual way to solicit patrons and most of them declined to buy. Obviously they found these watercolours beyond their comprehension. These works are indeed very elaborate, filled with detail and rendered with great precision. However they still manage to convey a fleeting image viewed through a finely coloured atmosphere. The impressive Swiss landscape seems to disintegrate in the hazy light, and it is really the colour which conveys the monumentality of the scene. 'They were not' says Ruskin 'in his usual style', yet he did purchase - he was one of only three patrons who did.[2]

Undaunted by the lack of enthusiasm the first series received, Turner presented Griffith with a second series a year later. Only six subjects were purchased this time, again by Ruskin and Munro. They were in the same style as the first series but Ruskin maintained they did not reach the supreme achievement of the first set. Not to be disappointed, Turner produced yet another series of ten subjects in 1845 in much the same sense of delight and exhilaration, although somewhat looser in detail.

After the 1844 tour, Turner was never again to visit Switzerland. His last two watercolours of Swiss landscape were executed in 1848 for John Ruskin - *View of the Brunig Pass from Meiringen* and *The descent of St. Gotthard*.

Three sketches of *Lake Lucerne* form part of the National Gallery of Ireland's collection. Two are similar in style and technique to the finished work of *Lake Lucerne: The Bay of Uri from above Brunnen* which was submitted to Griffith in 1841, but the viewpoint is slightly different.

1. Wilton/Russell 1976, p. 134.
2. Finberg 1939, p. 420.

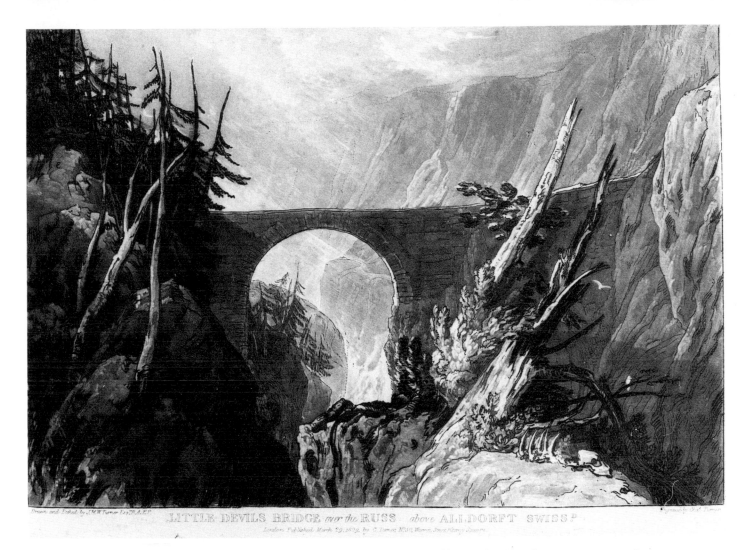

Little Devil's Bridge, Pass of St. Gotthard, Switzerland (National Gallery of Ireland, cat. no. 11,976). Mezzotint from *Liber Studiorum.*

Lake Lucerne: The Bay of Uri from above Brunnen 1841 (Pl. 34)

Pencil and watercolour on paper, 23 × 29.1 cms.

WATERMARK: *J. Whatman, Turkey Mill 1840.*

PROVENANCE: Henry Vaughan Bequest, 1900

LITERATURE: Armstrong 1902, p. 263; Wilton 1979, no. 1476.

Cat. no. 2427.

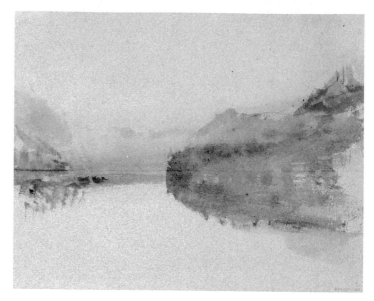

Fig. 43. *Lake Lucerne, Switzerland* (T.B. CCCLXIV-127, Tate Gallery, London). Watercolour.

Lake Lucerne was one of Turner's favourite haunts in Switzerland. The scene of William Tell's famous escape from his captors, the lake was a source of inspiration to the Romantics. Samuel Rogers in his poem *Italy*, for which Turner had provided the illustrations, described it as 'that sacred lake withdrawn among the hills.'

This watercolour is a dispersed sheet from one of Turner's roll sketchbooks, possibly the CCCLXIV sketchbook dated 1841. It is similar to the finished watercolour of *Lake Lucerne: The Bay of Uri from above Brunnen* submitted to Mr. Griffith as part of a sample series of fifteen in 1841, although the viewpoint is different. The Dublin work is more like another sketch from this book on page 127 (Fig. 43). In both of these sketches, of which the Dublin one is the more 'finished', Turner has blocked off the background to the right by the mighty Schillerstein. The daily activities of the local people are carefully recorded, as they are an important factor in the overall majesty of the landscape.

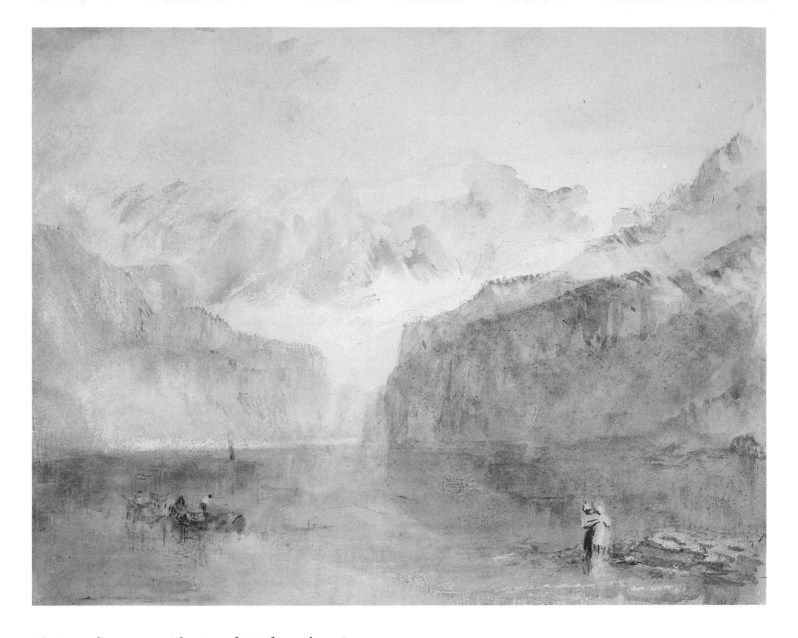

Pl. 34 *Lake Lucerne: The Bay of Uri from above Brunnen*

Sketch: Lake Lucerne from Brunnen 1841 (Pl. 35)

Pencil and watercolour on paper, 21.4 × 28.2 cms.

PROVENANCE: Henry Vaughan Bequest, 1900

LITERATURE: Armstrong 1902, p. 263; Wilton 1979, no. 1477.

Cat. no. 2428

Sketched from the same spot as the more 'finished' Lake Lucerne (Pl. 34) this view shows an early morning scene on the Lake. An evanescent atmosphere suffuses the scene, pierced by rays of the rising sun.

The slight rapid pencil sketches in the foreground record the daily activities of the local people, as in the other sketch of Lake Lucerne and underline their importance in Turner's overall design.

Pl. 35 *Sketch: Lake Lucerne from Brunnen*

A shower over Lake Lucerne

1841 (Pl. 36)

Watercolour on paper, 22.5 × 28.9 cms.

PROVENANCE: Henry Vaughan Bequest, 1900

LITERATURE: Armstrong 1902, p. 263; Wilton 1979, no. 1475.

Cat. no. 2422

Turner's mastery of watercolour is evident in this image of stormclouds gathering over the lake. A turbulent scene is conjured up in just a few broad colour washes. The bare white paper revealed in the foreground represents part of the water's surface.

Though we associate these atmospheric images with Turner's late work, there are examples of such watercolours in his early works.

Pl. 36 *A shower over Lake Lucerne*

Bibliography

Armstrong 1902
Sir Walter Armstrong, *Turner*. (London 1902)

Bell/Girtin 1935
S.F. Bell and Thomas Girtin, *The Drawings and Sketches of John Robert Cozens*. Walpole Society, vol. 23 (1935).

Bellinzona 1980.
Exh. cat., *Luci e Figure di Bellinzona*, A Cura di Virgilio Gilardoni Societa Bancaria Tilinese. (Bellinzona 1980).

Butler/Joll 1977.
Martin Butler and Evelyn Joll, *The Paintings of J.M.W. Turner*. 2 vols. (London/New Haven 1977).

Cunningham 1843.
A. Cunningham, *Life of Sir David Wilkie*, (London 1843).

Edinburgh, National Galleries of Scotland, cat. 1980.
National Gallery of Scotland, *The Vaughan Bequest of Turner Watercolours*. (Edinburgh 1980). Cat. by John Dick.

Farington 1978.
The Diary of Joseph Farington, edited by Kenneth Garlic, Angus MacKintyre and Kathryn Cave. 16 vols. Yale University Press. (New Haven/London 1978 - 1984).

Finberg 1909.
A.J. Finberg, *A Complete Inventory of The Drawings in the Turner Bequest*. 2 vols. (London 1909).

Finberg 1929.
A.J. Finberg, *An Introduction to Turner's Southern Coast*. (London 1929).

Finberg 1930.
A.J. Finberg, *In Venice with Turner*. (London 1930).

Finberg 1935.
A.J. Finberg, 'Turner's Newly Identified Yorkshire Sketch-Book', *The Connoisseur*, vol. 96, (October 1935).

Finberg 1939.
A.J. Finberg, *The Life of J.M.W. Turner R.A.* (London 1939), 2nd edition revised and edited by Hilda F. Finberg (Oxford 1961, 1967).

Gage 1969.
John Gage, *Colour in Turner: poetry and truth*. (London 1969).

Gage 1980.
Collected correspondence of J.M.W. Turner, edited by John Gage (Oxford 1980).

George 1971.
Handy George, 'Turner in Venice', *Art Bulletin*, vol. 53, (1971).

Herrmann 1968.
Luke Herrmann, *Ruskin and Turner*. (London 1968).

Hibbert 1986
Christopher Hibbert, *The Grand Tour* (London 1986).

Huish 1886.
Marcus B. Huish, *Turner - The Seine and Loire*. (London 1886).

Huish 1892.
Marcus B. Huish, *Turner - The Southern Coast of England*. (London 1892).

Jerusalem 1979.
Exh. cat., *Turner and The Bible*. Israel Museum, Jerusalem. (1979). Cat. by Mordechai Omer.

Köln 1980.
Exh. cat., *J.M.W. Turner, Köln und der Rhein*. Wallraf Richartz Museum, Köln (1980).

Lindsay 1985.
Jack Lindsay, *Turner: the man and his art*. (London 1985).

London 1973.
Sale catalogue, *Seven sketchbooks by J.R. Cozens with an Introduction by Anthony Blunt*. Sotheby's, November 29, 1973.

Lugt 1921
F. Lugt, *Les Marques de Collections de Dessins et D'Estampes*. (Amsterdam 1921)

Luxembourg 1984.
Exh. cat., *J.M.W. Turner in Luxembourg and its neighbourhood*. Musée de l'Etat, Luxembourg (1984). Cat. by Jean Claude Muller and Jean Luc Koltz.

Manchester/London 1971.
Exh. cat., *Watercolours by John Robert Cozens*. Whitworth Art Gallery, University of Manchester and Victoria and Albert Museum, London. (1971). Cat. by Francis Hawcroft.

Monkhouse 1878.
William Cosmo Monkhouse, *The Turner Gallery*. (London 1878).

Monkhouse 1879.
William Cosmo Monkhouse, *Turner*. (London 1879).

Moore 1853/60
Memoirs, Journal and Correspondence of Thomas Moore, edited by Lord John Russell, M.P. (London 1853/60).

Paris 1981/82.
Exh. cat., *Turner en France*. Centre Culturel du Marais, Paris (1981/82).

Rawlinson 1908.
W.G. Rawlinson, *The Engraved Work of J.M.W. Turner*. 2 vols. (London 1908).

Redding 1853
Cyrus Redding, 'The Late Joseph Mallord William Turner', *The Gentleman's Magazine*, (February 1853).

Ruskin 1851-52
John Ruskin, *Letters from Venice, 1851-52*, ed. by John Lewis Bradley (Newhaven/London 1955).

Ruskin 1878.
John Ruskin, *Notes; I. on his drawings by J.M.W. Turner, II. on his own handiwork illustrative of Turner exhibition at The Fine Arts Societies*. (London 1878).

Ruskin 1888.
John Ruskin, *Introduction to Turner's Rivers of France*. (London 1888).

Ruskin 1895.
John Ruskin, *Introduction to Turner's Harbours of England*. (Kent 1895).

Ruskin 1903-12.
Works of John Ruskin, edited by Sir E.G. Cook and Alexander Wedderburn. 39 vols. (London 1903-12).

Shanes 1981.
Eric Shanes, *Turner's Rivers, Harbours and Coasts*. (London 1981).

Smithsonian Institution 1983.
Exh. cat., *Master European Drawings from the collection of The National Gallery of Ireland*. (1983). Cat. by Raymond Keaveney.

Stainton 1985.
Lindsay Stainton, *Turner in Venice*. (London 1985).

Sutton 1971
Denys Sutton, 'The Pleasant Place of All Festivity', *Apollo*, (September 1971), pp. 168-75.

Thornbury 1862.
Walter Thornbury, *The Life of J.M.W. Turner R.A.* 2 vols. (London 1862). Revised edition, 1877.

Uwins 1858
Sarah Uwins, *A Memoir of Thomas Uwins*, R.A. (London 1858)

Wilton 1975.
Andrew Wilton, *Turner in the British Museum*. (London 1975).

Wilton/Russell 1976.
Andrew Wilton and John Russell, *Turner in Switzerland*. (Zurich 1976).

Wilton 1979.
Andrew Wilton, *J.M.W. Turner. His Art and Life.* (Fribourg 1979).

Wilton 1980.
Andrew Wilton, *Turner and the Sublime*. (London 1980).

Wilton 1982.
Andrew Wilton, *Turner Abroad*. (London 1982).

Wilton 1987
Andrew Wilton, *Turner in his Time*. (London 1987).

Yale 1980.
Exh. cat., *The Art of Alexander and Robert Cozens*. Yale Center for British Art, New Haven (1980) Cat. by Andrew Wilton.

Youngblood 1982.
Patrick Youngblood, '"That House of Art": Turner at Petworth,' *Turner Studies*, vol. 2, no. 2 (London 1982).

List of Works by J.M.W. Turner
in the National Gallery of Ireland

INDEX